the
PROFESSOR
& **THE
COED**

the PROFESSOR & THE COED

Scandal & Murder at THE OHIO STATE UNIVERSITY

MARK GRIBBEN

Charleston London
The History Press

Published by The History Press
Charleston, SC 29403
www.historypress.net

Copyright © 2010 by Mark Gribben
All rights reserved

Unless otherwise noted, all images are from the author's collection.

First published 2010

Manufactured in the United States

ISBN 978.1.59629.910.8

Library of Congress Cataloging-in-Publication Data

Gribben, Mark.
The professor and the coed : scandal and murder at the Ohio State University / Mark Gribben.
p. cm.
Includes bibliographical references.
ISBN 978-1-59629-910-8
1. Snook, James H. (James Howard), 1879-1930. 2. Murderers--Ohio--Columbus--Biography. 3. College teachers--Ohio--Columbus--Biography. 4. Scandals--Ohio--Columbus. 5. Ohio State University. I. Title.
HV6248.S66G75 2010
364.152'3092--dc22
20100172050017201

Notice: The information in this book is true and complete to the best of our knowledge. It is offered without guarantee on the part of the author or The History Press. The author and The History Press disclaim all liability in connection with the use of this book.

All rights reserved. No part of this book may be reproduced or transmitted in any form whatsoever without prior written permission from the publisher except in the case of brief quotations embodied in critical articles and reviews.

For my father

Contents

Author's Note — 9
Acknowledgements — 11

Part I. Crime and Investigation
Discovery — 15
Theora — 20
Meyers — 29
Snook — 32
Evidence — 42
Chester — 48
Loose Ends — 52
Third Degree — 56

Part II. Confession
"The Friendship Continued in a Very Intimate Way…" — 65
"She Considered It Her Right to Dictate My Movements…" — 70
"I'll Kill Your Wife and Your Baby!" — 74
"A Voluntary Statement" — 79

Part III. Justice
Public Opinion — 83
The Circus Comes to Town — 87

Contents

Strategy and Tactics	91
The Opening Act	95
Secrets Revealed	107
Endgame	113
A Picnic in the Death House	119
Bibliography	123
About the Author	128

Author's Note

The 1920s was an era of more than flappers, bootleg liquor and the "Lost Generation" of F. Scott Fitzgerald. The decade was indeed roaring, but more importantly, the 1920s are nearly equal to the 1960s in terms of complex social upheaval in the United States. During the third decade of the twentieth century, the staid morality of the Victorian era was firmly and finally being put to rest. Young people—particularly college students—were rejecting the traditional values of their parents and establishing their own standards of acceptable behavior.

"The youth of the 1920s were at once the product of change and the agents of change," wrote sociologist Paula Fass in *The Damned and the Beautiful: American Youth in the 1920s*. "They existed at a strategic point in history when their actions really did make a difference."

I only bring this before the reader to point out that Theora Hix's behavior was not so far outside the mainstream of her age cohort as many of the people involved in this case might have believed. A large percentage of well-educated young people of both genders was no less sexually adventurous than Theora, although as Fass points out in her book, most college women were monogamous and only engaged in intercourse with partners when the prospect of marriage was high. Studies at the time estimated that about 50 percent of college women were not virgins, and more than 90 percent engaged in some sort of sexual activity.

Acknowledgements

This book would not have been possible without the help and guidance of the Honorable Teresa Liston (Retired), Drs. Deirdre Wickham and Lisa Finkelstein, the personnel in the Ordnance Section of the Columbus, Ohio Division of Police and Diana Hill and Linda Deitch of the Columbus *Dispatch*. I am indebted to them for their help in explaining the law and medical aspects of the case and their assistance in procuring images and illustrations.

Part I
CRIME AND INVESTIGATION

Discovery

Paul Krumlauf and Milton Miller never did find out who was the better shot.

It was a fine summer morning, one of the last bright days before the arrival of the Great Depression. A powerful rainstorm had blown through the area the previous day, finally clearing away a stalled mass of warm air that had long since gone stale, leaving high, wispy tendrils of clouds in place of the ominous thunderheads that had been hovering close to the ground. A warm breeze was at work drying the weeds; the smell of wet earth lingered in the air.

The two teenage friends had been boasting of their sharpshooting skills and decided to settle the good-natured dispute by firing off a few rounds at a gun range on the outskirts of Columbus, Ohio; instead, they raised the curtain on a short morality play that thrust talk of infidelity and promiscuity, aphrodisiacs and illicit drugs, lust and murder onto the front pages of newspapers and into homes across the country. The secret double life of a not-so-innocent young woman would be laid bare, and a quiet, middle-aged married man would go down in history as the only Ohio State University professor—and Olympic gold medalist—to die in the electric chair.

About 10:30 a.m. on Friday, June 14, 1929, Krumlauf and Miller were wading through knee-high weeds toward the firing line at the New York Central railroad shooting range just west of the city limits to settle their bet when they saw a farmer plowing a field to the east. The boys headed over to warn the man, seventy-six-year-old Ephraim Johnson, that they were about

to do some shooting. On their way across the field, they stumbled upon a pile of something in the brush.

In a way, Fortune was merciful to the boys when they found the young woman's body. Because she was facedown in the tall weeds, they were spared the sight of the dozen or so wounds on her face caused by the hammer blows her killer had rained down. They did not see the gaping cut that ran across her throat nearly from ear to ear and the bizarre appearance of her face turned china white for want of blood. They did not know of the puncture wound to her ear where her killer had inserted his knife. Because the boys had found her just a little more than twelve hours after she had been murdered, the eggs laid in the open wounds by blowflies attracted to the dead flesh had not yet hatched into maggots. Her body was badly beaten and bloody, but what might have remained for the boys to discover could have been much worse.

At first they thought the crumpled body was an abandoned pile of clothes. After all, finding discarded clothing, liquor bottles and other refuse at the shooting range was not unusual.

A convenient drive from the Ohio State campus and the city, a secluded spot not far from the Scioto River road and the exclusive Scioto Country Club, the shooting range was popular with sportsmen and young people for different reasons. The remote location and the tall weeds made the area a prime location for "necking" (the term had recently replaced "spooning" in the slang of youths), giving it the moniker "Shirt-Tail Alley." More than a few couples had been ticketed there by the local constable and fined by the justice of the peace for "fornicating." The murder victim, in fact, had been arrested here and paid a twenty-dollar fine under a false name less than a year before.

The boys first heard, rather than saw, the crime scene because of the flies buzzing around the pooled and drying blood. Once the boys realized they had not found some discarded and forgotten clothing and that the thing in front of them was a person, the thoughts of the shooting contest were lost forever. They shrank from the sight and called to Johnson, who responded in his typical casual manner to the boys' frantic summons. Johnson agreed to watch over the body while the boys brought the police. Johnson, apparently, was nonplussed by the gruesome find: after he let the boys leave, he left the scene himself to put his horses away in the barn.

The boys raced Krumlauf's jalopy to the Parsons Avenue police station about ten minutes away. It took them an hour to return to the range with Corporal John May and Officer Emmet Cloud, who secured the crime scene

and waited for the arrival of the coroner and a crime-scene photographer from the state's Bureau of Identification.

Arriving soon after the first responders, Coroner William Murphy was met by a gruesome scene in the high grass. The woman's body was lying on its left side, with her right arm extended in front, the hand clutching a bloody handkerchief. Her throat had been slashed, apparent stab wounds were visible on her back and abdomen, her nose had been flattened, her face was battered almost beyond recognition and most of the bones in her skull were broken. Her hair was matted with blood.

She was clothed in a blood-saturated, belted, brown crepe dress with white collar that covered a "combination suit ripped from the waist to the hem, the garment which modern times had developed, two garments in one made to meet the needs of the busy girl," wrote Anne Schatenstein, one of the many reporters who covered the case.

Murphy, who had been coroner for Franklin County since 1921 and had seen his share of murder victims, waited until Homer Richter, the police photographer, took a couple of pictures and then helped him turn the body over. The first thing he noticed were the four bruises on the inside of her left arm and the corresponding bruise on the outside.

"She was held by someone with a strong grip," he said, gesturing toward the purple contusions. Murphy assumed this meant she had tried to flee from her attacker.

The coroner noted that the victim's throat had been cut from left to right with a sharp knife and that there were three wounds on her forehead: two blows on the left side and one above her nose that he said later "had the appearance of a puncture within an incised wound, which I supposed was made by a blow." One of the wounds above her eye was large and deep enough that he could insert his finger into it, he said.

Affixing the time of death was a simple affair. When the men turned over the body, Murphy saw that the woman was wearing a wristwatch. The crystal had fallen out, and the hands were stopped at 9:58. That clue corresponded with the temperature and rigor condition of the body. The watch still worked; once Constable John Guy lifted the arm, it started to run again.

At first, Murphy wondered if he was dealing with a horrible sex crime. "I noticed a wound in the right groin, and that her underclothing had been cut practically by the same instrument to a distance up to where would be practically a band and then another distance about three inches above the band," he testified later. "But the dress had not been cut in that position."

After his cursory review of the scene, Murphy ordered the unidentified woman to be taken to the Glenn L. Meyers Mortuary for an autopsy.

Early on in the investigation, Columbus Division of Police detectives drew some erroneous conclusions, demonstrating the folly of reading too much into a crime scene. Their incorrect assumption of a lunatic on the loose—the Columbus Hospital for the Insane was a stone's throw away from the scene—was fast revised, thanks to the newspapers that did not sit for long on the discovery of the body of a young woman so brutally murdered. Shortly after the *Columbus Evening Dispatch* published the first sketchy reports that Friday afternoon, the police were redirected from their search for a homicidal maniac who snatched his victim from the city and dumped her corpse in that lonely field, to an even more shocking investigation, which revealed not only that the deceased had gone to the shooting range willingly but also that she knew her killer in a most intimate way.

That is not to say that the newspapers were overly helpful or even enlightened. The *Dispatch*'s rival paper, the *Columbus Citizen*, reported that unnamed "Washington, D.C., scientists" believed the murder was the result of "the blind and absolutely uncontrolled, even unconscious, rage of the epileptic."

Discounting the possibility that the killer was a sadist who had gone too far in punishing his victim, or that he was "delusional" or "obsessive," because even those madmen will stop before "more is done to the victim than is necessary to extinguish life," the *Citizen* claimed that epileptics have no such control. "During the course of the seizure he is absolutely unconscious of his acts," the unsigned and unsourced article states. "He is in an amnesiac state. He is not aware of what he is doing at the time, and has no memory of it afterwards."

The newspapers' clarion call of murder achieved its objective: it sold papers and prompted people with information to step forward. In some cases, police are besieged with false leads, sham confessions from the mentally ill and specious theories from armchair detectives. Not so in this case. With very few exceptions, the tips passed along to the police actually had some bearing on this murder.

The first task in any murder investigation is to identify the victim, which in this case did not prove difficult. Around the same time Krumlauf and Miller were breathlessly telling of their gruesome discovery, two sisters, Alice and Beatrice Bustin, were wondering why their roommate, Theora Hix, had not returned home the night before. The three women shared a small flat above the State Drug and Supply Company, about a block away from Mack Hall

Scandal and Murder at the Ohio State University

on the OSU campus. As a roommate, Theora was an enigma to the Bustin sisters, but she had never stayed away from the apartment overnight without telling them. They were perplexed but not overly concerned. Theora led her own life, quite separate from the Bustin sisters.

"We didn't become alarmed when she didn't come in when it became bedtime Thursday night, for she was in the habit of taking walks in the evening, and when she didn't return at all during the night we thought she had stayed with the Jeffers where she used to stay with the children occasionally," Alice said later. "It wasn't until late in the day that we began to get worried and called the police."

When the papers hit the street on the late afternoon with news of the murder, the Bustin sisters were not the only ones to suspect they knew the identity of the body found at the shooting range. Bertha Dillon, a switchboard operator at the Ohio State University hospital, had been more than a little miffed when the young woman she had been training, Theora Hix, had not returned from a date the night before.

Hatless, and attired in a brown dress trimmed with a flashy rhinestone belt that was uncharacteristically gaudy for her, Theora sat with Bertha for an hour or so Thursday evening, learning the layout of the switchboard until she announced that she had a date and would be back shortly.

"She came in Thursday evening to see me operate the board," Bertha told police. "She appeared about the same as usual—she never smiled much—but shortly after 7:30 she told me that she would have to be going but would be back later. She smiled when she spoke of her date. It was one of the few times I had ever seen her smile. She was always so quiet and serious-minded."

The police brought the Bustin sisters and Bertha Dillon to the mortuary, where they viewed the body of the shooting range murder victim. All identified the battered corpse as Theora Kathleen Hix, an Ohio State University medical student two months shy of her twenty-fifth birthday.

Theora

Police now had a name, and with it came a photograph of the victim: a casual sorority photo showing a fresh-skinned, moderately attractive young woman with close-cut hair, clear, bright eyes averted from the camera and a knowing expression somewhere between a Mona Lisa smile and a smirk. It is, of Theora Hix, a perfect representation—enigmatic and beguiling, a mysteriously simple photograph that hints at carefully concealed secrets.

The investigation now centered on tracing Theora's last earthly hours for clues to her killer's identity and explanations for why she had to die.

The first solid lead came from taxicab driver Earl Nickles, who had picked up a distracted young woman answering Theora's description near Neil Avenue around the time Theora left Bertha Dillon at the OSU switchboard. Neil Avenue is one of the main north–south streets that borders the OSU campus and runs directly into downtown Columbus.

"She seemed all worried," he told the *Dispatch*. "She told me to drive to the Hilltop and said that she wanted to go by way of Grandview Avenue. She said she thought she might see a man in a coupe.

"She asked me for cigarettes three times going over but didn't smoke more than a part of each one," he added.

When the woman failed to find what she was looking for at Sullivant Avenue and Eureka Street in the Hilltop district, she told Nickles to drive back to Neil.

"She asked for two more cigarettes on the way back but didn't smoke more than two puffs on each one," he said. "She was all fidgety about something."

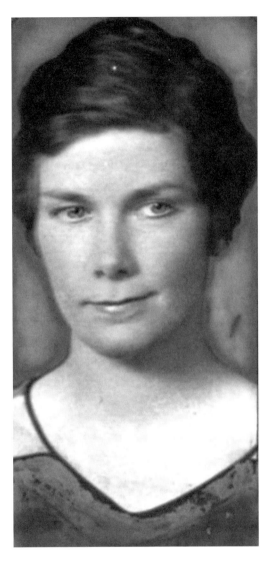

The most frequently used photograph of Theora Hix.

Theora's nervous behavior was not the only reason Nickles remembered the fare. Theora directed the cabbie to drive a sixteen-mile circuit along a meandering route that was much longer than necessary. Directing Nickles to use Grandview Avenue took Theora in the opposite direction of the Hilltop area. The trip that took nearly an hour might have been accomplished in half that time if they had used the most direct route then available. Police learned later that the trip took Theora past a number of locations of significance in her secret life.

Nickles dropped the woman off at Neil and Tenth Avenues near the OSU hospital and didn't give the fare a second thought until the papers reported the murder. Other witnesses picked up the story. More than one person confirmed that the woman Nickles let off was seen in the company of an older, bald-headed, bespectacled man driving a blue coupe.

The deeper the police looked into the life of their murder victim for clues, the more mysterious Theora became. Everyone they located who was acquainted with Theora really did not know her at all. Detectives found no shortage of persons willing to step forward to say what a pleasant, polite, hardworking young woman she was, but no one had the least bit of information about her that was not superficial. The Theora everyone knew was a quiet, intelligent, somewhat standoffish co-worker or roommate—nothing more. She was as inscrutable as the Sphinx, surrendering her secrets to no one.

"Theora was an unusual girl in some ways," Alice Bustin said. "She lived here in the apartment with Beatrice and me since last September, but we didn't know much about her."

She played tennis—on the municipal courts near the shooting range—and golf and liked to take walks, the Bustin sisters said. She was a good worker and showed up on time, said her boss in the veterinary school stenographer's pool.

"She came here…after the conclusion of her examinations for full time work but no one in the office really knew her and we never saw her with anyone except another girl who called for her for luncheon," Mrs. J.H. Wright, assistant to the dean of the OSU graduate school, told reporters hungry for any scrap of information about the reclusive murder victim.

The newspapers launched their own investigations into the background of the mysterious victim. The less people knew of her, the more driven the papers became to solve the riddle that was Theora Hix.

Those who spoke kindly could only call her shy and retiring; the less charitable called Theora moody. Of men, however, everyone was of the same opinion: Theora had little interest in them, and anything she did with men she kept to herself.

"She chatted freely with us, but both Alice and I knew that it was practically useless to ask her how she liked her date the preceding night, what she did, where she went, or with whom she dated," said classmate Flora Pedicord of Zanesville, Ohio. "She wouldn't tell us."

She seldom dated, but her acquaintances and roommates said that she might have been making time with an older gentleman who was connected

to the university. She did not talk about it; they did not press her and had no idea who that man might have been.

"She never told us a word and we never attempted to draw her into such conversation," Pedicord said, adding that "rumors were persistent that she had been keeping company with a man and that a few months ago had a quarrel with him. After that she appeared to enjoy herself more with her girl friends." She added ominously that there were additional rumors that Theora had once again taken up with that man.

Theora had always been a reticent date, friends recalled. "When we had a party it was always necessary to make a blind date for Theora," a high school classmate tracked down in Muskegon, Michigan, told the *Dispatch*. "She never wanted to go with the same man twice."

Detectives going through Theora's belongings came across her bank passbooks, which only deepened the mystery. The investigators found one account at the Buckeye Building & Loan Association that contained $615 and another that indicated she had closed an account at the Columbian Building & Loan Association containing $1,863. At one time, Theora had enough money to buy a top-of-the-line Buick sedan for cash with money left over or put down 50 percent on a home in Columbus. Needless to say, it was unusual for a college student, even a working student on a stipend, to have banked so much money. No one, including her family, could say where Theora had gotten the funds. Her father told investigators he gave his daughter $600 annually for living expenses. Her hidden assets were particularly puzzling because Theora was known on occasion to take advantage of the university's short-term student loan program.

Equally shocking was the .41-caliber Derringer that Theora kept in a drawer.

Police found several letters signed "Janet" that Theora saved, which convinced them that the young woman was living a double life. It was likely that at least one was really written by a man: "You recall that I showed you a little place and had you feel it, and which, severed, would prevent possible trouble. Well, I have been wanting to snip them both for some time…So thinking that this was a good time to try, I did fix the little one only, did it as soon as I came back. It was simple and easy, and all went well until Friday."

The writer goes on to describe how during a golf match some "swelling occurred…and an annoying pain" like "a long sharp, smooth ice-pick." The letter expresses some concern about a forthcoming visit: "There is a chance I may not be able to come up. And if I do come up, may not be able then." The last sentence was underlined.

The other letters contained musings that the detectives thought might—presuming the letters were actually written by another woman—explain why Theora was not overly interested in men. One described a painful separation between Theora and the letter's author, written when an apparently despondent Theora was living away from Columbus.

> *My Dearie…I am surprised to note that you put your entire condition of forlornness and turbulousness on the one thing and wish you never had. You once told me that you would never say that. Neither do I believe it…I could be contented just to be with you, omitting special features, and think you could also. I hope you will reconsider and can blame conditions rather than just the other.*

Another hinted at a physical relationship between Theora and the mysterious "Janet."

> *My Dearie: Awakened early about seven and of course thought of you at once. Wondered how tough it makes one feel for you to awaken, turn over, reach before opening your eyes, and found no one. I know because I did it yesterday. 'Tis awful…*
>
> *And I never had such a joke as when I closed the door, clicked the key and reached for you; a long trip, all anticipation, no chance soon again, and I was greeted with a "No; I don't want to muss my hair" and "I'm hungry." Can you imagine anyone doing that? And further to sit quietly through a show for three hours more.*

It was the newspapers that uncovered Theora's more distant past, but there was little insight gained from it.

Born on Long Island, New York, Theora was the only child of a couple who had been married twenty years and had given up hope of ever becoming parents. Theora began her education in the New York City public school system, where her father, Melvin, was a principal. She came to Ohio State University by way of Northfield Seminary in Massachusetts, where she graduated as the single senior in the class of 1922. Northfield is a storied East Coast college preparatory school with a long résumé of illustrious graduates. Religion was important to the Hix family, and that prompted them to take advantage of the Northfield Seminary's mission to provide a first-class education to "young people who had limited access to education because they were poor," according to the school's history.

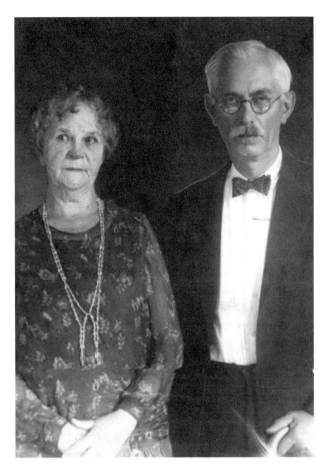

Mr. and Mrs. Melvin Hix, parents of the murdered woman. *Courtesy of the* Columbus Dispatch.

"Because we desired her to have in every respect the best moral and religious influence we sent her to the Northfield Seminary," Melvin Hix told the *Dispatch*. (The school was prestigious, but it was not safe from scandal. Six years after Theora's murder, a popular headmaster at the Northfield men's seminary was slain by a sniper who shot him through a study window as he worked at his desk. The case remains unsolved.)

On the surface, she took the education to heart. Theora, whose name, her father told the papers, meant "god-given" in Greek, was an only child who had always expressed an interest in medicine and told her family that she was planning a career as a medical missionary.

"When her mother and I went to the graduation exercises all of her teachers came to us and praised her as to ability and character in the highest terms," the grieving father told the paper when he arrived in Columbus.

"She had been asked to act as a kind of monitor in her house. When girls wanted to go out or go shopping they were told they could go if Theora Hix would go with them.

"On account of her dignity and reliability and good sense she was trusted as no other girl in the house was trusted," he continued. "Her teachers told me this and her fellow students will bear witness to that effect."

Although she was considered trustworthy and respected by her peers—the 1922 school annual, the *Gemini*, describes how "her quiet and unassuming ways have won for her a warm place in the hearts of her many campus friends who would be glad to have her nearer"—the yearbook also hints at Theora's adventurous side: "Her steadfastness of character and her loyalty of spirit have contributed much in upholding the standards of Northfield. Occasionally, however, 'Teddy' waxes frisky; if you do not believe it, ask her how to use the fire escape ropes."

While the police looked at Theora's more current activities for clues, the papers marked time and kept the story alive by digging up what they could about her past. Above her high-school graduation photo, the *Dispatch* headlined a story: "Miss Hix most bashful and worst man-hater in prep school" and reprinted a poem written about her by a Northfield classmate:

> *On a platform in a city square*
> *Theora Hix did stand*
> *And from her mouth did come,*
> *The words "Down with man!"*
> *All through the country she has traveled*
> *This cry to all to make known.*
> *For she has become a believer*
> *In woman asserting her own.*

Melvin Hix told reporters that he had feared his daughter might come to harm. "From her childhood she had one quality that caused some anxiety," her father said. "She was fearless. Physically I do not think she knew the meaning of the word fear and we often warned her that evil men might attack her unaware, as they had done to so many girls."

This part of Theora's personality was repeatedly shared by her acquaintances, who all said she may have been shy and retiring but was also self-confident and dauntless when aroused. Her desire to obtain a medical degree when being a physician was still very much a man's profession demonstrates this. Others said that Theora, who was larger and more

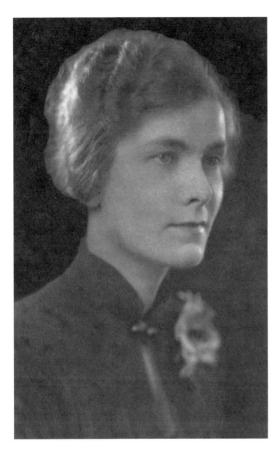

A portrait of Theora Hix. This photograph was not used by the press until the end of the trial. *Courtesy of the* Columbus Dispatch.

muscular than many women, was equally confident in her ability to protect herself physically.

Almost everything the newspapers turned up failed to make Theora a sympathetic victim. While her parents insisted she was brought up with morals and traditional values and her employers and acquaintances reported that she was dependable and courteous, those descriptions did not mesh with a hatless, cigarette-smoking, "man-hating" young woman who did not attend church, had not visited her parents in more than a year and apparently had several thousand dollars secreted away in a couple of bank accounts around town. The fact that no one really knew Theora Hix meant that there was something there that Theora did not want people to know, the papers claimed—in not so sympathetic terms, as this unsigned United Press article shows.

One of the cleverest actresses on the stage of life.

That was one characterization of Miss Theora Hix which was heard today as the investigation following her murder continued to reveal startling facts about this quiet Ohio State co-ed.

Theora played a dangerous role. But she played it well, she knew her exits and entrances. She knew her lines. She had her campus audience completely oblivious of her other life behind the scenes.

This co-ed of mystery moved so surely, so deftly through her part that those who considered themselves her closest friends are the most startled as facts regarding the girl's activities are brought forth.

Her stage was the Ohio State campus, and she played the part of a poor girl working her way through the hard, tedious medical school. She was quiet, with an English, old-fashioned attractiveness. In the role she acted before her classmates, there was no love interest, nothing to indicate that her relations with men were not of the most casual kind.

She borrowed money from University loan funds to carry out the part she was acting. She accepted various jobs, none of which paid excessive salaries.

But behind the scenes she had a large bank account, larger than that of most students. It is a mystery where she obtained much of this money.

She often denied having dates. Men did not seem to interest her to any great extent.

There are other facts now known which her campus group never suspected.

Which was the real Theora Hix? The quiet, unassuming co-ed? The woman revealed by the investigation?

Many think she was acting a part for her classmates, a few think her campus appearance was the real Theora and her other life was acted for some deep motive, still unknown.

Regardless of the answer, many admire the skill with which she kept that secret life hidden, a life that led to some tangle which caused her murder.

She was a good actress. Her campus audience never suspected she was playing a part.

Then death rang down the curtain.

Meyers

Investigators got a break in the case from one of the few men who could be considered a beau of Theora.

At 3:15 a.m. on Saturday, June 16, a man called the Columbus Division of Police from nearby Lucas County and asked if Theora Hix had been killed. When the operator pressed for more information, the man said he was "just a friend" and rang off.

The call came from Marion T. Meyers, a thirty-five-year-old horticulture expert from the agriculture department at Ohio State University who had once been more than just a friend to Theora Hix. Meyers was a 1921 graduate of Ohio State from Hillsboro, Ohio, living at the Gamma Alpha fraternity house near campus and once was so enamored with Theora that he had proposed marriage. That proposal and her laughing rejection ended the relationship, but Theora and Meyers remained cordial.

A few hours after he called, Meyers walked into the Columbus police station, inquired about the woman found at the shooting range and was promptly arrested, held on a forty-eight-hour "investigation charge" and interrogated. He admitted he was in Columbus on the Thursday evening Theora was killed but denied having anything to do with her murder. Meyers had been in the field working on a corn borer infestation problem Friday when a fraternity brother told him that Theora had been killed. He called the police department, confirmed that a woman had been murdered and headed back to town.

Although Meyers had an alibi for much of Thursday night—he was seen by several fraternity brothers at the Gamma Alpha house where he

was living—the investigators subjected him to a rigorous interrogation, as he was the only person who seemed to have any insight into the personality of Theora Hix.

As a jilted suitor, Meyers was a prime suspect, and while he could account for himself much of Thursday night, there was a problematic thirty-minute gap where he had stepped out to mail some letters. Theora also ended her ride in the taxi not far from where the Gamma Alpha house stood. Meyers did not help himself early on; the newspapers reported that their police sources believed he was holding back critical information. Acting on the naïve belief that his innocence would be proved and he would soon be free, Meyers did act like a man with something to hide. He was clearly shaken by events, and his naturally nervous temperament fit the profile of someone with a guilty conscience. His answers to even basic questions were vague and lacking in detail, making him appear to his interrogators to be uncooperative. Meyers also fit the description of the man last seen with Theora—a bald-headed man somewhat older than the woman he was with. Meyers, known to his friends as "Baldy," suffered from premature hair loss.

At the time, Meyers's claim that his relationship with Theora had cooled since the previous autumn did not jibe with what police thought they knew of him. He admitted that he and Theora had been physically intimate but said the relationship ended when she rejected his marriage proposal. His interrogators knew from talking with Alice and Beatrice Bustin that Theora was spending time with an older man connected to the university and thought that man was Meyers.

Meyers experienced intense questioning before sharing with the police that there was another man from Ohio State University in the picture. Meyers said he did not know much about him, but that his name was Dr. James Howard Snook. The graduate student denied writing the letters found in Theora's room and suggested that they had come from Snook. Even after he introduced Snook into the case, Meyers remained near the top of the suspect list. Pointing the finger at another person is the most common practice by suspects. He would not have been the first man to vent his anger on a woman who had forsaken him for another. He may have been upset about his former lover's slaying, but he had a strange way of showing it.

"I don't care about Theora," Meyers said. "I only want to help her poor parents."

Not to be outdone by the *Citizen*'s supposition that Theora had been slain by an epileptic in the throes of a grand mal seizure and the United Press correspondent's essay on "Theora the actress," the *Dispatch* used the news

of Meyers's detention, his relationship with Theora and the presence of another man—as yet unknown to the press—to lay the groundwork for a speculative story of a sinister love triangle.

"I wanted to see her Thursday night but I was afraid to," the *Dispatch* quoted Meyers as reportedly telling an unnamed police officer. "I was afraid that something would happen. I suppose I'll be charged with murder. I'll tell the whole truth."

The fact that he had sex with Theora did cost him, however. Soon after his arrest, Meyers was fired by the president of Ohio State University for "moral turpitude." The summer of 1929 turned out to be a very bad one for poor Marion Meyers. Within a period of just a few months, he lost both parents, his job and the friendship of a woman he had once wanted to marry.

The *Dispatch*, however, was quick to reassure its readers that all was not bleak for Meyers. Baldy's current fiancée was quick to stand by her jailed betrothed. Thanks to a source inside the city's Western Union station, the paper got hold of several telegrams from Miss Eleanor Ricker of Wooster, Ohio, and shared them with the public: "Shall I come? Don't Worry. Let me know if I can do anything. Love." And later: "Thinking of you every moment. Keep stiff upper lip." The *Dispatch* subsequently revealed via the Western Union source that "Mildred" had come to be with Eleanor and that she was "confident everything will work out," leaving it to readers to discover who Mildred was and why they should care about her faith in Meyers's eventual vindication.

After interviews with Theora's employers at OSU and particularly with Marion Meyers, the investigators were anxious to interview Dr. Snook, whose description also matched the man seen driving with Theora and who had worked closely with her during her service in the school steno pool.

Snook

At 9:30 a.m. on Saturday, Detective Larry Van Skaik and James Fusco, a reporter for the *Citizen*, knocked on the front door of the home Dr. Snook shared with his wife and their two-year-old daughter. They were met by the professor, in suspenders and shirtsleeves, who was about to sit down for breakfast. The men noticed that Snook's right hand was bandaged.

The detective invited Snook to step outside, which he did.

"Do you know Theora Hix?" Van Skaik asked, and Snook admitted that he did.

"I think it is necessary for you to go with me to headquarters for investigation," Van Skaik said.

"May I have my breakfast?" Snook asked.

Van Skaik was not about to wait around for Snook to eat.

"Yes, you can," the cop replied. "If you think it is best for me to tell your wife what I want you for."

Dr. Snook paused for a moment and looked down.

"Oh," he said, finally. "Can I drive my own machine?"

Van Skaik inquired about Snook's bandaged hand. Snook told him he had hurt it while repairing his car on Wednesday. The detective helped Snook tie his tie and draped the professor's suit coat over his right shoulder.

The detective and the reporter drove downtown with Snook following them in his two-seater. They stopped at the Geis Restaurant in the 300 block of Broad Street, not far from the police headquarters, and the three men had breakfast.

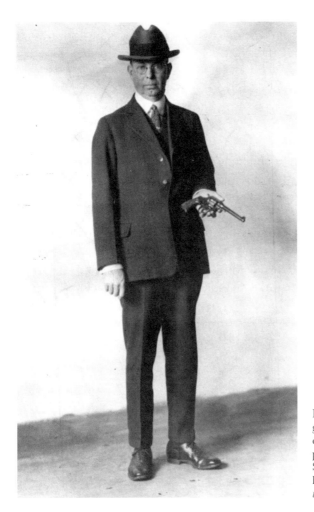

Dr. Snook was an Olympic gold medal winner and champion pistol shot. This photo was taken by the Ohio State University years before his murder trial. *Courtesy of the* Columbus Dispatch.

The conversation must have been extraordinarily mundane and the meal less than memorable; in a story where even the most minute detail was printed, Fusco, the reporter, never made mention of it in the paper. For Snook, however, the trip was notable for several reasons. He would never return to his home, and that breakfast would be his last meal as a free man.

Dr. James Howard Snook was a taciturn forty-nine-year-old professor of veterinary science who had worked at Ohio State University since graduating from there in 1908. Tall and fit, Snook was smooth-shaven, but with a thick, dark beard that gave him the perpetual appearance of having a five o'clock shadow. His hirsute face contrasted with his bald head and its close-shorn hair that wrapped around the back of his head from ear to ear.

With his round wire pince-nez clipped to his nose, he appeared as what one would expect a quiet, established college professor to look like. For the most part, his public life was typical of a man in his situation. He was well regarded as a veterinarian both by the school and the community and received the grateful thanks of a farming community for halting an outbreak of hog cholera in Fayette County in 1914. During the Great War, he served as an instructor at an aviation school.

At the time of his arrest, Snook had several claims to fame: he had been the American rapid-fire pistol shooting champion eight times in the past and won a gold medal for pistol shooting as a member of the 1920 United States Olympic team in Antwerp, Belgium. He was also the inventor of "the Snook Hook," a surgical instrument for dog and cat spaying procedures that remains in use today.

Snook had a well-rounded education and was a cultured and charming companion, friends said. He was a member of the exclusive Scioto Country Club in Columbus and a pair of shooting clubs that frequently used the New York Central range where Theora's body was found. Snook married Helen Marple in 1922, and the couple had two children: a son who died in 1925 and a daughter who was a month shy of her second birthday when he was arrested.

(A curious aspect of the Snook case is the way the newspapers treated Snook's daughter. Nearly every other personal detail of anyone connected to the case in the most remote way was exposed to public view: the name and address of Snook's widowed mother was published shortly after his arrest; his wife's pedigree was printed; telegrams from Marion Meyers's fiancée were shared with readers; reporters trailed the prosecutor to visit his family physician and questioned him about it, but the name of Snook's daughter was never published. Details of her birth and christening were made public, as was the death of her older brother, but her identity was off-limits.)

Van Skaik brought Snook to the office of Police Chief Harry French, where for the first time the professor met his nemesis, Franklin County prosecutor John J. Chester Jr. Also present were Chief of Detectives Wilson C. Shellenbarger and Detective Otto Phillips. Van Skaik turned his prisoner over to the group and returned to the crime scene for further investigation. Meanwhile, other officers were examining Snook's blue coupe.

This first meeting was friendly and the interrogation low-key. Although he was under arrest on an investigation charge, Snook was not a suspect, like Meyers, but a "person of interest." The point of the interview was to find out what Snook knew rather than to push for a confession. Each of the

officers present commented later about Snook's cool demeanor in contrast to Meyers's disquiet during questioning.

Snook acted like a man who had nothing to hide. Snook admitted that he had met Theora in 1926 at work and that he had once given her a ride during a rainstorm. There was another young woman from the steno pool with them at the time. Beyond that, there was nothing between them beyond a casual office familiarity. Even that, Snook told his questioners, was distant, as Theora was not prone to engagement in blithe conversation.

It is a typical police interrogation technique to ask a suspect to speculate on what happened during the commission of the crime. Frequently, a guilty suspect has trouble inventing a plausible alternative scenario on the spot and will sprinkle his story with facts known only to the criminal and tips for officers to follow up. Shellenbarger posed the question to Snook, who did not hesitate to offer his hypothesis of the crime.

"My theory is based on an acquaintance with Miss Hix," he started. "I am inclined to believe she took a ride with someone she did not know."

"Was she the type of girl who would let herself be picked up a lot?" Shellenbarger asked.

"She changed a lot in the last year or so," Snook responded. "She got the idea she knew a lot about people and could handle them. I knew of one ride she took and had to scrap to get out of it. The taxi ride sounds funny."

"So she would fight if forced to do so?" Chester asked, noting that this statement conflicted with Snook's claim of unfamiliarity with Theora.

"She was not hot tempered," Snook replied. "She would talk rather than fight. Miss Hix was a diplomatic girl."

Snook told his interrogators that he last saw Theora on Wednesday afternoon and gave a step-by-step accounting of his time on Thursday. The story was such that there were a number of alibi witnesses that police would have to track down to confirm it.

"Thursday night I got to the office at about 7:30 or 8 o'clock and did some typing," Snook said. "I finished one article for the *Hunter, Trader, and Trapper* magazine and began another."

Chester asked Snook when he left the vet school and if anyone had seen him. No one was around, Snook replied.

"I left the office Thursday evening at 8:40 p.m. and went to the Scioto club, arriving just before 9 o'clock. I saw two or three persons I knew and then went back to town," Snook continued. "One the way home I purchased a newspaper and arrived at the house about 9:30 p.m."

Shellenbarger then turned up the heat a bit, using information supplied by Marion Meyers.

"Did you ever loan money to Miss Hix?" he asked.

"Two years ago," Snook began before pausing to gather his thoughts. "Two years ago she wrote to me from New York City and asked me to meet her in Pittsburgh. I got the impression she was in financial straits. I did not go. I sent Marion Meyers instead. He was friendly with her at the time."

"Why would she write to you, Professor?" Shellenbarger asked.

"We did take some rides together," Snook admitted. "I was negotiating with her to type a manuscript for a book I was writing."

"So you would say you knew her more than just…what did you say," French looked at his notes. "You knew her more than just 'casually.'"

Snook simply shrugged his shoulders and did not reply.

French switched subjects.

"You're a crack pistol shot, Dr. Snook aren't you?" he said, not waiting for a response. "Miss Hix had a Derringer in her room. Did she get that from you?"

Snook stiffened visibly when the pistol was mentioned but quickly recovered his cool. The detectives noted his response but dismissed it because no firearms were involved in Theora's death. The blunt force trauma could not even be blamed on a handgun's grip.

"I loaned her the pistol because she was afraid," he said.

"Afraid of what?" Shellenbarger asked.

"She liked to walk at night and until a short time ago she lived alone," Snook said. "I gave it to her for protection. We talked of shooting, she wanted to learn how to shoot with a .22 caliber Winchester rifle and a .22 single-shot pistol. After a scare some weeks later, I gave her the Derringer. The rifle was a 10-shot magazine, automatic affair, which was very pleasant to shoot…"

Snook stopped talking when he realized he had just confirmed in no uncertain terms that his relationship with Theora was anything but "casual."

The interview ended. Phillips escorted Snook down to the Franklin County Jail, where he was slated and photographed. As mug shots go, Snook's is nothing special except that his is one of just a few where the arrestee is wearing a tie. He appears tired, and his lips are pursed in a look of concern. His signature circular pince-nez dominate his unshaven face. Snook stares blankly into the camera, but there is no confidence in his face. Still, it is one of the most emotional photographs of him in the case record.

There were a number of forces at work against Snook at that time. Investigators looking at his car found some peculiar stains on the passenger side door and on the upholstery. The discolorations looked like blood. The

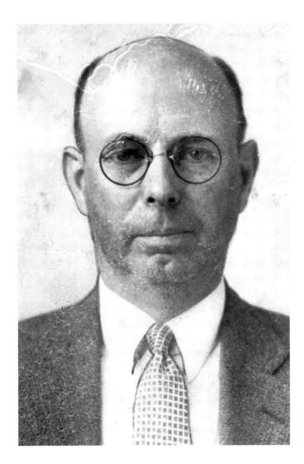

Dr. James Snook's mug shot taken by the Columbus Division of Police.

city chemist, Charles F. Long, was summoned to examine them further. Behind the seats, searchers found a number of curious objects, including a "woman's umbrella," a glove apparently stained with blood and a hairpin. Across town, Detective Howard Lavely had executed a search warrant at the Snook home. Detective Van Skaik was back at the crime scene intending to look for clues but fending off a throng of hundreds of relic hunters eager to find some gruesome trinket connected to the crime.

Lavely returned from the Snook home with mixed results. He failed to find the weapons used in the killing or anything linking Snook to the crime, but he did make a discovery that demanded an explanation from the professor. The remains of a fire were smoldering in the incinerator in the basement. Amongst the normal household trash, Lavely found several pairs of men's pajamas and a man's shirt that appeared to be bloodstained. He also reported that there were some articles of "a feminine nature," but they

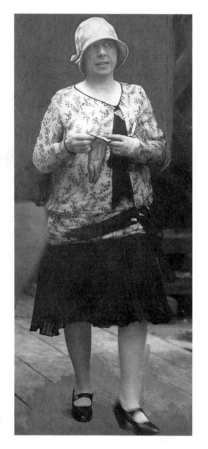

Mrs. Helen Snook. *Courtesy of the* Columbus Dispatch.

could not be tied to Theora. Helen Snook could not explain the pajamas but said she had been burning trash on Friday. The shirt, she supposed, was covered in animal blood. She said it was not unusual for her husband to burn clothes that had been soiled at work.

In her first interview with authorities, Helen said that she was upstairs getting their daughter ready for bed on Thursday when she heard her husband enter the house at about 9:30 p.m. Lavely did not press Helen on whether she actually saw her husband come into the home at that time. It was a significant question that should have been asked, but Lavely was unaware of what was happening down at headquarters with Snook and his inquisitors.

Van Skaik was even less successful, coming back empty-handed. The crime scene had been trampled by hundreds of curious civilians since the crime had been reported, so attempting any kind of forensic crime scene examination was useless.

"Women have come with small children in their arms or toddling at their side to see the site of the murder," the *Dispatch* reported. "Men have come with girls. Boys have come without number and aided for a few minutes in the search until the monotony of the task drove them away."

The high grass had been flattened in a 150-foot radius from the crime scene, covering any evidence with a thick blanket of weeds. It would be a miracle, he thought, to find anything of value. He made a note to contact Franklin County sheriff Harry Paul to get a jail work crew out there to cut the weeds.

The murder did have at least one unintended consequence for the shooting range. "There wasn't a night that three or four cars weren't parked here in the shadows," a farmer who lived nearby said a few days after the killing. "But not since the murder. Girls aren't going to let their fellows take them where some other girl had her throat cut by her fellow. Thinking about it wouldn't make for kissing."

As the detectives regrouped at police headquarters, a witness who would move the case into a surprising new direction was about to contact police.

Margaret Smalley read about Snook's arrest in the first edition of the *Dispatch* Saturday and realized she had important information about the

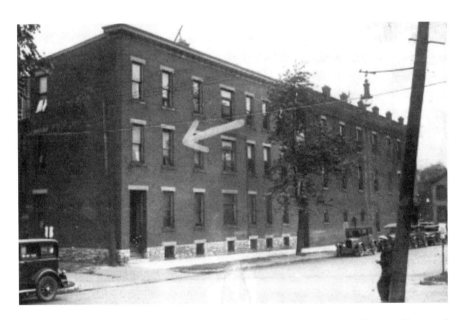

The Hubbard Avenue apartment building where Snook and Theora would meet. *Courtesy of the* Columbus Dispatch.

case. She did not know Dr. James Howard Snook of Columbus or Theora Hix, but she did know Mr. Howard Snook of Newark, Ohio, a city about thirty miles east of Columbus. The middle-aged Howard Snook and his much younger wife, whom Smalley knew only as Mrs. Snook, rented a small room from her on Hubbard Avenue near North High Street, a mile or so south of the Ohio State University campus, in February 1929. Mr. Snook introduced himself as a salt salesman and said his wife was a "demonstrator."

Mrs. Smalley called police headquarters after she recognized her tenant and asked that they send "a plainclothes man" over to her home. Detectives Otto Phillips and Robert McCall were soon at her door.

"I saw Mr. Snook once a week when he came to pay the $4 weekly rent," she said in her statement. "It would be sometimes Wednesday and sometimes Thursday and sometimes as late as Friday. I only saw Mrs. Snook once. It was a Saturday, the day I usually cleaned their room. I was a little early and I met her in the hall as she was leaving."

Snook and Mrs. Smalley would exchange the same pleasantries each time he came to make a payment.

"Well, I would always say, 'How do you do, Mr. Snook?' And if it would be later than Wednesday he would say, 'Well, this is Wednesday,' and I would say, 'That is all right, Mr. Snook.' That is all that would be said."

The flat, dubbed the "Love Nest" by reporters, was small and dominated by a large brass bed and a single wood high-backed armchair. It overlooked the rear of the apartment house and allowed the couple to come and go discreetly through a back entrance.

Mrs. Smalley then dropped a comment that made investigators change their view of the professor. Snook had appeared at the rooming house sometime between 1:30 and 3:30 p.m. on Friday, June 14, while the landlady was washing dishes and informed her that he was giving up the room. He was moving to Washington Court House, a city about halfway between Columbus and Cincinnati. His wife, he added, was not leaving until Sunday, and she would leave the two keys to the apartment inside it. The detectives immediately searched the small room and found it empty except for a lady's brown hat and two keys.

Smalley and the cops drove to the Meyers mortuary, where she positively identified Theora as the woman she knew as "Mrs. Snook." They all then headed to headquarters, where Snook was returned to the detective bureau from the jail.

The doctor was presented to Mrs. Smalley, who casually said, "Good evening, Mr. Snook."

"Good evening," Snook replied.

"Do you know Mrs. Smalley?" Detective Phillips asked Snook.

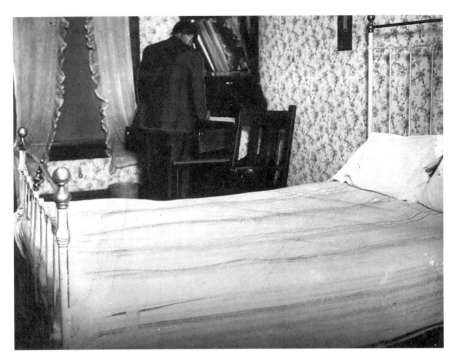

Inside the "love nest" that Dr. Snook and Theora Hix rented. *Courtesy of the* Columbus Dispatch.

"Yes," he said. "I roomed with her."

"Was Miss Hix your wife when you roomed with Mrs. Smalley?" the detective pressed.

"Yes," Snook said.

After the encounter with Mrs. Smalley, the police returned Snook to his cell. It was late, and the officers needed time to digest the information they had uncovered during the long day. The fact that James Snook and Theora Hix had been lovers took the case in a new direction, but to the police at least, it did not worsen the doctor's situation. After all, it was possible that Marion Meyers, in a jealous rage, had killed Theora. Or even Helen Snook, the wronged wife, might have murdered her rival. If anything, this new revelation that Snook had feelings for Theora made it less likely that he was the killer. Until the results of the tests on the stains from his clothing and the car came back, there was nothing left to do but wait.

It was about 9:00 p.m. on Saturday night; Theora Hix had been dead only forty-eight hours, but the electric chair was beginning to cast its long shadow over Dr. James Howard Snook.

Evidence

At the mortuary, Coroner Murphy was more concerned with Theora's physical condition than her lifestyle. The first postmortem examination revealed that she was the victim of a vicious attack that clearly showed signs of what investigators call overkill—the clear use of significantly more force than is necessary to slay. In most cases where overkill is present, the murderer has suffered psychological distress for which the victim or someone whom the victim resembles or represents is, innocently or otherwise, the source.

After a preliminary autopsy, Murphy presented his findings to police, blaming the blunt force trauma on a hammer.

> *Wound number one. Number one is an incised wound about one and one-quarter inches long in the middle of the forehead, the center of which has the appearance of a puncture wound and extends through the frontal sinus, but does not fracture the vault of the skull, and was made by the small end of the hammer.*
>
> *Number two and number three wounds, on the right side of the forehead were made by the flat end of a hammer.*
>
> *Number four is on the left side of the forehead and it was made by the flat end of a hammer.*
>
> *Number five is an incised wound on the left side of the neck, four and one-half inches long; beneath the skin there is (sic) two distinct wounds which severed the jugular vein and the carotid artery on the left side; on the top of the head there are five lacerated wounds, four of which were made by*

> the small end of a hammer, which fractured the skull; another made by the flat end of the hammer also fractured the skull.
> In all there are 12 other lacerations on the back of the head, one a puncture wound in the right ear. Small pieces of bone were removed from the occipital and temporal bone, below the right ear, which left a hole in the skull two and one-half by one and one-half inches.
> The cerebellum was badly lacerated by the bones being driven into it.
> There is no blood clot in the brain. Both hemispheres are congested, but little blood is found.

Murphy's report describes the bruises on Theora's arm, a broken right hand and some superficial cuts on her back that he supposed were made by a knife but could not be sure. A key result of the postmortem was Murphy's considered opinion that Theora died as a result of the wound to her neck, not the blows from the hammer. The hammer wounds had stunned the woman, but she was still alive when her killer slashed her throat with his knife.

The coroner submitted Theora's internal organs to Long for analysis. Neither man expected to find what was left in her stomach. The half-digested roast beef sandwich was not unusual, but the *Cannabis indica* in a powder form and *cantharides* were. *C. indica* is a type of marijuana that, according to marijuana aficionados, offers a high of a different sort (many users claim it is more of a sedative-like effect) than its more common relative, *Cannabis sativa*. *Indica*, grown primarily in eastern hemisphere regions, is often used to make hashish.

Cantharides, or Blister Beetle extract, has a more notorious street name: Spanish fly. Although its effectiveness as an aphrodisiac in human beings has been refuted, *cantharides* is used in animal husbandry to induce animals to mate. Its function is purely physical. It does not make the male animal more amorous; it merely helps him become able to perform sexually. In other words, veterinarians and breeders use Spanish fly as animal Viagra. Contrary to popular perception, it does not have any effect on females except to increase blood flow to the urinary tract. It is easy to overdose on Spanish fly; rather than increased physical stamina, the overdosed user instead experiences painful urination, fever, possible permanent damage to the kidneys and genitals and death.

Police were now confronted with the question of whether Theora had knowingly ingested marijuana and Spanish fly or if her killer had surreptitiously drugged his victim. Their first assumption was that she had been drugged because no one questioned had ever known Theora to use alcohol or drugs of any kind.

The Professor and the Coed

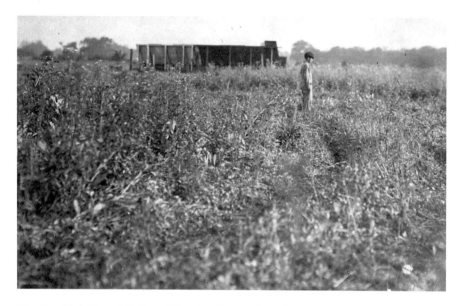

The New York Central Railroad Shooting Range where Theora Hix was murdered. *Courtesy of the* Columbus Dispatch.

Detectives tracked down a suit belonging to Snook that he had dropped off at a dry-cleaning establishment on the Friday before his arrest. There appeared to be stains on the jacket sleeve and pants that might have been blood. The suit was turned over to Long for testing.

As he had planned, Van Skaik brought a group of prisoners who swung idiot sticks languidly, cutting down the weeds. The detective was especially keen to find the murder weapons. One of the prisoners quickly found a rust- or blood-stained kitchen paring knife that Van Skaik sent to the chemist. The hammer was not recovered, and Van Skaik held out little hope that it was at the scene. The newspapers estimated that more than five thousand people had visited the crime scene in the hours after the murder, and Van Skaik believed that someone would have stumbled across the hammer. He doubted that even the most ignorant farm boy would want to keep the murder weapon as a relic of the biggest murder in Columbus history. Both telephone operator Bertha Dillon and cabbie Earl Nickels told police that Theora had a purse with her the night she died, but no one had found it yet. Until the purse turned up, the police could not reject the theory that Theora was the victim of a robbery gone horribly wrong. Like the hammer, Van Skaik did not expect to find it at the murder site.

Once the weeds had been cut down to a manageable height in an oval about ten by fifteen feet, Van Skaik and the deputies ordered the trusties on their hands and knees to scour the ground for any clues. It did not take long for one of the prisoners to uncover something. The man yelled out and stood up, motioning to Van Skaik, who straightened up, brushed the mud from his knees and headed to where the prisoner waited just a few feet east of where Theora's body had been found.

"Don't touch it!" the detective yelled.

Looking down, Van Skaik saw a key chain—broken—with three keys still attached.

By the time Van Skaik decided to call it a day, the group had found twelve keys and the kitchen paring knife. Heading back to the detective bureau, Van Skaik was thinking of the two keys found in the love nest. Had one of them belonged to Theora? he wondered. If so, how did it get into the flat on Friday?

The chemist Long was busy testing evidence for the presence of blood. He had taken swabs from the passenger-side door of Snook's two-seat coupe as well as from the shirt found in the Snook incinerator and from the pants and jacket retrieved from the dry cleaner. Understandably, blood is one of the most common pieces of evidence connected to a crime of violence. Today, bloodstains can help identify the location of a crime scene, the weapon used to perpetrate the crime and the criminal who committed it, but at the time Theora was killed, it could do little more to help the investigation. Blood typing—whether the blood is Type A, B, AB or O—was available to Long, but until 1932, typing was only possible for liquid blood. DNA analysis, now a common test for bloodstains, was decades away. For Long, the only tests possible were to determine first that the stains were blood and, if so, that they were human blood. As Snook was a veterinarian, the second test was critical.

Sunlight, heat, bacteria and the age of the stain affect the appearance of blood, which can turn gray or nearly invisible when dry. During the course of clotting, blood separates into a clear liquid and clotted red blood cells. The stain takes on a "target-like" appearance, with the clear portion surrounding the colored clot.

The first test Long applied was the presumptive test for blood. Using a diluted solution of phenolphthalein, alcohol and potassium hydroxide, followed by a dose of hydrogen peroxide, he conducted the Kastle-Meyer test. He first dabbed the stain with a swab dipped in distilled water, added the phenolphthalein solution to the swab and rubbed it on the stain. Then

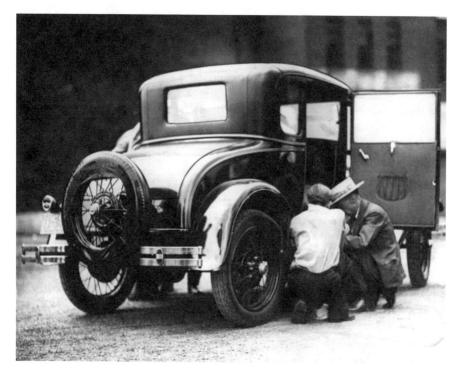

Crime scene technicians examine the Ford coupe driven by Dr. Snook. *Courtesy of the Columbus Dispatch.*

he applied a few drops of hydrogen peroxide. On each of the stains, the chemicals reacted as he predicted: the phenolphthalein solution turned bright pink while the hydrogen peroxide bubbled ferociously. The Kastle-Meyer test is useful for investigators but is not 100 percent reliable and is not appropriate for courtroom settings. In addition to blood, the Kastle-Meyer test also gives false positives in the presence of rust, potatoes, copper, bleach and horseradish.

Long, however, was nearly positive that the stains were not any of these and proceeded with the precipitin test, which differentiates between animal and human blood. This test indicated that the blood was human, not canine, as Snook had claimed. The chemist skipped the presumptive test on the rusted paring knife and applied the precipitin test. The inconclusive results and Coroner Murphy's belief that the blade was too dull to make the smooth cut on Theora's throat caused the two men to concur that it was probably not the murder weapon.

It was Long who had examined the stomach contents taken from Theora Hix and isolated the cannabis and Spanish fly. Both substances were relatively

undigested, suggesting to him and Murphy that they had been taken at the same time as the roast beef sandwich. Working from the naïve assumption that Theora would not knowingly have taken the hallucinogen and purported aphrodisiac, the scientists theorized that she had been drugged by eating an adulterated sandwich.

At the time, there was no chemical test Long could apply to confirm the identity of either substance. Instead, he examined the marijuana, which had been leached into a white powder, under a microscope. He followed up his visual analysis with a physiological test involving a pair of dogs taken from the local pound. Testing the effects of marijuana on dogs was the only accepted clinical test available at the time.

With a representative of the Humane Society watching, Long gave one of the dogs a known amount of *cannabis indica* and the other a similar-sized sample of the contents from Theora's stomach.

"The effect at first was a drowsiness, then a twitching of the muscles generally, particularly the hind, and then general incoordination," he wrote in his report. "Stimulation followed that very rapidly. The dog (with the contents from Theora's stomach) began to exhibit the effects about 50 minutes after ingestion. The effects lasted perhaps two hours and a half."

A conversation with Dr. O.V. Brumley, who worked at the OSU vet school, confirmed that both *cantharides* and *cannabis indica* were freely available from the school's pharmacy. Despite the marijuana's status as a controlled substance, there was no process for limiting access to the drug. Detective Lavely searched Snook's office and found a jar of *cantharides*. Brumley said he had seen the bottle in Snook's office, adding that it had been there for several years. Spanish fly has a medicinal purpose in the veterinary lab, he said.

"We use Spanish fly in the form of ointments for external application or blistering effect," Brumley said. "It is listed as an aphrodisiac, but we have never used it for that purpose."

Chester

Sunday was a quiet day for the parties involved in the Theora Hix murder. Melvin Hix arrived in Columbus from Bradenton, Florida, to claim his daughter's body and was shocked to learn from police of Theora's relationships with Meyers and Snook. "I have nothing left but a broken heart," Hix told reporters when he left the Meyers mortuary after viewing his daughter's body.

The various suspects, persons of interest and others connected to the crime used the rest of the weekend to find lawyers, as did the Hix family.

On Monday morning, Prosecutor Chester convened the Franklin County grand jury, prompting speculation that a murder arrest was near. In fact, the grand jury met every Monday, as the Ohio Constitution requires that every felony case be presented to the grand jury for indictment. Chester used the grand jury summons to bring in the minor players connected to the Hix case, getting their statements on the official record. The grand jury adjourned in the early afternoon once its regular business was finished and no indictments related to Theora's murder were handed up. One of the witnesses before the grand jury was Melvin Hix, who refused to accept the statutory one-dollar compensation for a grand jury appearance.

John Chester Jr., described by the press as "the boy prosecutor," was young and new on the job as prosecutor, but he was not inexperienced in representing the people. Before beginning his service as the Franklin County prosecutor in January 1929, he served as prosecutor in the Columbus police court. There was no doubt in his mind, however, that the Hix murder was the biggest case he had ever faced, and he attacked it with dogged determination.

Scandal and Murder at the Ohio State University

A more seasoned prosecutor would have allowed the police to do their job, but Chester was fanatical in his pursuit of a solution to the case. Under normal circumstances, the prosecutor, although he is the chief law official in an Ohio county, does not conduct the criminal investigations—that is the role of the police. However, Chester inserted himself into the middle of the Hix murder investigation almost immediately. He was present during most interrogation sessions, and rather than serving as the department's legal advisor during this phase of the case, Chester usurped control from Chief Harry French and commanded the investigation. There were any number of reasons why Chester would step in where he was not needed, none of which reflect very charitably on him. Perhaps he wanted to establish himself as the chief law officer in Franklin County in more than just name or because the high-profile nature of the case could open the door to more and better things. In any event, French stepped aside and let Chester call the shots.

The boy prosecutor may have been a great legal mind and a more than competent lawyer—one of the preeminent Ohio law firms bears his name—but he was not a cop, and he did not have a detective's instinctual ability to know how to question a suspect. At the time, Chester knew only one way to get the information he wanted: the aggressive cross-examination of a prosecutor.

Chester set the tone for his relationship with Snook's defense team when he denied Snook's lawyers, retired judge John Seidel and E.O. Ricketts, an opportunity to talk to their client. At first, Chester refused to allow the lawyers any access to their client, causing Ricketts to bang his fists on the door to the detective bureau where Snook was being questioned. The prosecutor relented a bit and allowed Ricketts and Seidel to speak with Snook with police officers present.

For Ricketts, an emotional and capable criminal defense lawyer, five-minute meetings with a client in the presence of the police were insufficient. When a sheriff's deputy refused to allow them access to Snook, the defense team was forced to get a mandatory injunction from Common Pleas Court judge Dana F. Reynolds.

By modern standards, Chester's actions seem outrageous and a violation of Snook's Sixth Amendment right to counsel. But in 1929, the Sixth Amendment to the U.S. Constitution only applied to federal criminal matters. It would not be until 1961 that the Supreme Court held that the Sixth Amendment applied to state criminal trials, and even then the Sixth Amendment only factored into courtroom proceedings, not custodial interrogations. The Ohio Constitution was silent on the idea of a suspect's

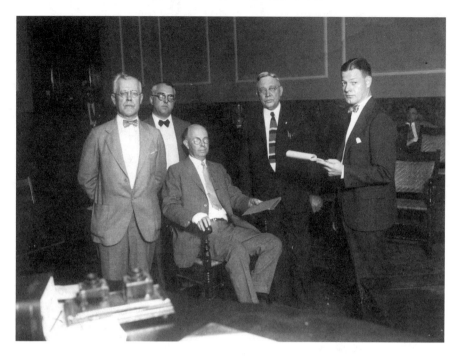

Dr. Snook (seated) surrounded by Sheriff Harry Paul, John Seidel, E.O. Ricketts and Prosecutor John J. Chester Jr. *Courtesy of the* Columbus Dispatch.

right to legal counsel. As far as the law was concerned, suspects like Snook were on their own.

Too late for the morning *Citizen* but timed perfectly for the *Dispatch*'s early edition, Detective Lavely took Snook on a trip to the love nest and the murder scene. At this point, Snook had been spared the ordeal suffered by Baldy Meyers in being forced to view Theora's remains at the mortuary. The papers reported that Snook was cool at the murder scene, "except for a slight shudder when he looked upon the blood-stained grass where the body of the girl was found." Reporters were not allowed to accompany the group into the apartment, so what happened there remains a secret.

Also on Monday, Ohio State University president George Washington Rightmire dismissed Snook from the university faculty. Meyers and Snook were not the only OSU employees to be terminated over the Hix murder. When an investigation and audit criticized the Ohio State University Veterinary School, Dean David White was held responsible and forced to resign.

A sketch of Dr. Snook that appeared in the Columbus *Citizen*.

White was collateral damage in the excitement surrounding the first days of the Theora Hix case. When Snook falsely alleged that Theora was a drug addict who hounded him for cocaine and marijuana, the federal narcotics bureau briefly got involved in the investigation and found that the controls over the drugs in the vet school were lax. The university could not let such a lapse go unpunished, and White, despite a stellar career in building the veterinary school into one of the nation's top programs, was chosen as the sacrificial lamb and pushed into retirement.

Loose Ends

Jittery from sitting incommunicado for a weekend in the county jail, on Tuesday Meyers was once again interrogated by police. His alibi checked out, and the discovery of the love nest certainly helped his case, but Snook told police that Meyers was "insanely jealous," once throwing a temper tantrum when Theora chose to spend time with the professor rather than her former beau.

In a last effort to try and break his resolve, police loaded Marion Meyers into a prowl car, drove to the home of Franklin County prosecutor John Chester Jr. and from there dragged him to the mortuary where Theora's body lay. They were acting on the archaic belief that a guilty party, when confronted with the gruesome fruits of his crime, could not help but confess. The papers reported that Meyers was reluctant to enter the room where Theora lay and that he only did so after a sharp push between the shoulders from Lavely. The viewing did not have the desired effect; rather than confess, Meyers simply broke down and wept like a man who was faced with the reality that a woman he once loved had been murdered.

The *Dispatch*'s description of the incident is a powerful example of the papers' hunger for any scrap of news. As newsmen watched, Chester, Lavely and Meyers sat in a car outside Chester's home, talking.

> *Presently, a coupe drove up and parked in front of Chester's car. Lavely and Chester conferred briefly with the visitor, the identity of whom Chester did not reveal. The car bore a license plate issued to Frank H.*

Schwartz, 123 North Ardmore Road, associated with the Columbus Showcase Co.

Schwartz denied that his visit had anything to do with the murder case but said he was returning from a swimming party and stopped when he recognized Chester's car parked in front of his home. Schwartz remained parked in his car in front of Chester's residence after Chester, Lavely and Meyers left for the mortuary. Shortly thereafter a sedan drew to a stop at the Chester home. Two or three couples were in the car, but one couple, clad in bathing suits and beach coats, left the car and the girl peered into Chester's sedan. Presently both returned to their car and then the girl went into Chester's home and the car drove away.

The article then describes, turn by turn, the route Chester and company took to a nearby drugstore, where they were joined by Dr. J. Quinn Dorgan, whose role in the visit was never explained. Dr. Dorgan never reappeared in the case.

Tuesday marked the first intensive interview of Helen Snook by Prosecutor Chester, who was still trying to establish the motive for Theora's death. Although prosecutors do not have to present a reason for a killing to get a conviction, motive and murderer go hand in hand. Finding out why Theora had to die would undoubtedly lead to who wanted her to die. The wife of a wayward husband is always a good suspect when the lover turns up dead.

The first thing Chester did when Helen Snook arrived with John Seidel was to push the attorney from the room, explaining that because he represented her husband, Seidel could not serve as her lawyer. "I'm happy to help you find your own attorney, Mrs. Snook," Chester said as he shut the door in Seidel's face.

Without bothering to wait for Helen to react to his offer, Chester moved ahead with his interrogation. He broke the case down for her, presenting the cold facts in rapid-fire order. Her husband had been unfaithful. He had rented a love nest for his paramour, a young woman from Ohio State University, who was now dead. Hairs had been found in her hand, hairs that resembled Helen's. The young woman's throat had been cut from ear to ear. A household paring knife was found near the murder site (Chester did not share with Helen that the knife had been rejected as the murder weapon). Did Helen have a paring knife in her kitchen? The prosecutor also failed to share with her that human blood had been found on her husband's clothes. That would come later, once he had eliminated Helen as a suspect—which he fully expected to do soon. He did believe that she knew more than she was willing to tell.

To Helen, the implication was clear. Chester thought she had murdered Theora Hix.

Helen denied even knowing of the existence of Theora Hix before Saturday and was unequivocal in her denial of having killed the rival for her husband's affections. She had not known of the apartment until she was informed by Seidel shortly before coming downtown on Monday.

Seidel did not simply stew about Chester's dismissal. He contacted a friend, Edward J. Scharnbarger, who agreed to represent Helen. He arrived at police headquarters just as Helen was tearfully denying any involvement.

"If you think she did it, arrest the girl!" Scharnbarger demanded, which served as his introduction to the investigators.

Chief French stepped in to defuse the situation. "Mrs. Snook," he said in a more gentle tone. "Tell us once more what you were doing on Thursday night up until the time your husband came home."

Helen told the men she had taken the baby for a walk before it started to get dark and then returned home and gave her daughter a bath. She sat upstairs reading after putting the baby down for the night and heard the screen door slam.

"Is that you?" she called out but received no answer. The fact that no one responded to her call did not upset her; more often than not, James did not reply to casual queries. She did not repeat the call but went back to reading.

"What time was that?" Chester asked.

"Around 9:30 p.m.," Helen answered.

"So you did not see your husband at that time, is that correct?" French asked.

"I did not," she said. "But I assumed it was him. It was not unusual for him to stay downstairs and fix a late lunch."

"Lunch? At almost 10 o'clock?" French looked puzzled.

"Well, that's what he called it. He would come home late and fix a sandwich or something before going to his room."

"When did you first see Dr. Snook that night?"

"It started to rain around 11, I think, and I got up to shut the windows," Helen said. "I saw him in the kitchen then."

"What was he doing?" Chester asked.

"Standing near the dining table. There was a sandwich on it."

"Mrs. Snook," French said softly. "Do you really think it took your husband an hour-and-a-half to make a sandwich and eat it? Isn't it possible that the door slamming you heard at 9:30 was caused by the wind or something?"

Helen waited a few beats before answering.

"I suppose it could have been."

Chester finally had enough evidence to make him consider Snook as his prime suspect. The prosecutor was satisfied with Meyers's alibi—there was no way he could have met Theora, drugged her, taken her to the shooting range, brutally killed her (undoubtedly covering himself with blood) and returned to the fraternity house unruffled and clean in thirty minutes. Chester ordered Meyers freed.

"As soon as we learned of his relations with the girl we were suspicious of (Snook)," Chester said later. "Meyers told us Snook was her lover. We did not suspect Meyers of the killing, but it was necessary that we should hold him a while in order to check the stories Snook told us. Meyers has an aptitude for getting mixed up in trouble when he is actually innocent."

Shellenbarger used Meyers as a lesson for anyone else who might end up as a witness to a crime. "There was no evidence to link him to the crime and if he had told a straightforward story from the start his release would have come more quickly," the detective said.

Third Degree

On Wednesday, July 19, Chester convened his investigative team to go over the evidence against Snook:

- Theora was last seen riding in a blue coupe. Snook owned such a car.
- There was blood on the passenger-side door of Snook's car that was human blood—not dog blood, as Snook claimed.
- There was human blood on the doorjamb, while Theora's right hand was broken and bloody. The break could have been caused by having her hand slammed in the door.
- Investigators found the bloody shirt in the Snook incinerator. The blood was human, and the cops felt the injury to the professor's hand could not explain it away.
- Snook said his hand injury occurred on Wednesday, but a physician said he had dressed the wound on Friday.
- The stains on the suit Snook dropped off at the cleaner on Friday were bloodstains.
- Snook gave up the apartment the day after Theora was murdered, left her key along with his own and removed her clothing there. Those clothes might have been the women's articles found in the incinerator.
- Detectives found a hammer and pocketknife with blood remnants in Snook's garage.
- Snook had Spanish fly in his office, as well as a number of books about sex. To investigators, this indicated a deranged mind.

- Snook's alibi was flimsy. No one at the Scioto Country Club could recall seeing Snook at the time he said he was there Thursday. No one could confirm that he was at his office Thursday night. Most importantly, Helen Snook admitted she did not see her husband until 11:00 p.m. Thursday.
- Witnesses said Snook unwillingly left a golf game on the Sunday before Theora was killed. This could indicate some discord in the relationship.
- Snook was wrong about the day he said he washed his car. He claimed it was Wednesday, but a vet school employee said he washed it on Friday.

Circumstantial evidence—the kind of evidence that requires the jury to infer other facts that may reasonably follow—all by itself had sent many criminals to the electric chair, but juries like direct evidence that proves a particular fact. Chester had no such evidence. More importantly, he could not explain to a jury why James Snook would have killed Theora Hix. Establishing a motive for a crime is not necessary to get a conviction, but prosecutors spend a great deal of trial time attempting to explain a defendant's actions to satisfy the jury's curiosity.

For the defense, attorneys Ricketts and Seidel only had to point out that there was a reasonably rational alternative to the prosecution's explanation of the chain of circumstantial evidence. They did not have to prove anything or even explain why Snook's story differed from the facts. So what that there was blood in the car—prove when and how it got there, they could argue. Prove that the cut on Snook's hand could not account for the blood on the clothes. So what if no one could recall seeing him on Thursday. Perhaps the professor and the coed had an argument Thursday and she stormed away from him, only to meet with her killer later on, they could argue. There are plenty of other explanations for all of the evidence the state could present.

To Chester, this meant only one thing: he needed a confession.

Sometime in the mid-afternoon of that cool overcast day, Dr. Snook, "looking refreshed and confident," according to a witness, was taken from the city jail to an interrogation room in the detective bureau. He was met by Chester, French, Lavely, Shellenbarger, Phillips, Van Skaik and McCall. A gang of reporters waited in the hallway outside the bureau, kept in check by several uniformed officers. A police stenographer sat outside the room, waiting for the inevitable confession that was to come from Snook, willingly or otherwise.

Chester immediately confronted Snook. "You killed Theora Hix and we know it," Chester said confidently yet in a friendly tone. "You beat her to death with a hammer and cut her throat. Tell us how it happened."

Snook simply shook his head. "I'm sorry I can't establish my alibi any better," Snook said to his questioners. "It seems all confused. I met some friends at the club, but they don't remember seeing me."

The interrogators began with questions about the toilet articles Snook admitted taking from the apartment. Where were they? Snook told them that he had removed them in a black medical bag and that everything could be found in his office. The towels, he warned them, could possibly have blood on them from his injured hand. Try as he might, Snook could not convince the officers that he had hurt himself adjusting the plugs in the Ford coupe.

"I used a styptic pencil, but by Friday it had become infected," he explained. "That's why I had it dressed by the doctor."

As the inquisition wore on, the investigators caught Snook in lie after lie. At first he said the brown hat found in the love nest was left behind by the previous tenants, but on another occasion he admitted that he bought it for Theora.

The detectives got Snook to admit he had removed the articles from the apartment and put them in the incinerator, but the doctor claimed he did so after he read of the murder and realized the victim was Theora.

When Snook said he returned home after going to the country club and cooked some hamburger, the officers pounced. "Your wife said you did not cook anything and the hamburger can was unopened," Phillips countered. The doctor did not reply.

He could not say when he had ever had a bleeding dog in the coupe, and besides, the blood was not animal blood anyway.

The script for Snook's interrogation could have been written by Warner Brothers and could have been filmed on a Hollywood sound stage.

The room was neither too small nor overly large. There was enough space for everyone to sit or walk about if they chose. The frosted glass door let in just enough light from the bureau and muffled the sounds of telephones and typing, making the outside world seem far away. Although the room was several stories above ground, the height of its window—above the head of a standing man—gave one the impression of being in a cellar. All of the questioners were smokers, and the air in the room quickly became gray and smelled of burnt tobacco. The oscillating fan atop a filing cabinet tried and failed to circulate air drawn from the open window.

None of the officers in the room expected the confession to come easily, and it did not. The inquisitors worked in shifts, tossing questions at Snook from every part of the room in a rapid-fire fashion. Afterward, the consensus among them was that it was the "most intensive and nerve-wracking in the history of the police department."

Outside the bureau, the reporters could hear raised voices and snatches of conversation.

"You're the most detestable creature on earth—you wouldn't care if your nearest relative were charged with murder" was shouted loud enough to be heard by reporters waiting in the hallway.

Snook's response was inaudible, if he answered at all. In the early going, Snook held the advantage and remained cool and collected. He sat in a straight-back chair, rocking back and forth, Lavely said later, as they went through the evidence point by point.

"You have lied yourself out of every alibi you ever had," Chester said.

Chief French, who had taken on the role of "Good Cop," added his two cents. "I have known men to go to the chair on less than you have told me," he said. "If you go out on the street and ask anyone that you meet what they think of the case, they will believe you guilty."

Lavely, one of the "Bad Cops," chimed in. "You will never get any rest until you sit in the electric chair."

By 1:45 a.m., Snook was worn down. He had told his story more times than he could remember, and each time he stumbled over a fact or told it differently the detectives called him on it. He said later that he felt "nervous, muddled, and contradictory." But still the grilling continued.

Phillips finally pushed Snook to the breaking point around 6:30 a.m. Thursday morning.

"Every key Theora had has been accounted for," Phillips said. "All of them were found at the scene except one. The key to the apartment. How did you get that key?"

Snook said Theora gave it to him on the Monday before the murder.

Phillips decided to bluff. "That's not true," he said. "She showed the apartment to her friend Peggy the day she died. Peggy can testify to that. Where did you get it?"

Peggy was a real acquaintance of Theora's—one that Phillips was sure Snook had at least heard of. The detective had no idea whether Peggy even knew Theora had a secret life, much less a key to a clandestine rendezvous. It was a long shot, and Phillips knew it. He was banking on the fog that had settled over Snook's brain.

Still, Phillips was shocked by Snook's response.

The professor was pacing the room with his hands in his pockets, looking at the floor. Phillips could see the muscles in his jaw twitching and realized that he had somehow hit a nerve. "You know where I got it," Snook said, and he began to weep.

For Phillips the cop, Snook's noncommittal answer accompanied by tears was good enough. He considered the professor broken and knew that it would be just a few more seconds until he admitted that he had taken the key from the girl's purse as she lay dead. Then Chester entered and said something Phillips couldn't hear, and in that instant Snook found his backbone again.

"I want to speak to my lawyer," he said.

The detective clenched his fists and shot an icy glare at Chester. Phillips left the room, and Chester followed him out after saying he would summon John Seidel and get Snook some breakfast. Snook was taken to a holding cell, where he wept quietly while Chester contacted Seidel.

Chester found Shellenbarger speaking to reporters, telling them that Snook had confessed to the murder. Chester was dumbfounded and immediately told the newsmen that no confession had been made. He pulled Shellenbarger and Phillips into French's office, where a shouting match that could be heard by the reporters ensued. Phillips insisted that Snook's statement about the key was as good as an admission that he got it from the girl's body and took the opportunity to point out that if Chester had not interrupted, he would have had Snook spilling the whole story in a matter of minutes. Shellenbarger agreed with Phillips, but Chester was adamant.

"I want a 'point-blank' confession that is specific," he shouted back, heading for the door. "Not anything less."

Chester was livid and told the press that no confession had come from Snook, that no one other than himself could release any news of a confession and that any paper that printed anything about a confession would regret it.

Still in damage-control mode, Chester pulled a groggy John Seidel, who had appeared at the police station without a jacket or tie, into the detective bureau.

"John Seidel, if you don't get that man to confess, damn you, I'll ruin you," Chester said. "I'll give the newspapers the whole story."

Seidel was taken aback by Chester's threat. "I'll be damned if you will," Seidel shot back. "But if there is any confession in that man I'll wheedle it out of him and give it to you."

"Ten minutes," Chester said. "You have ten minutes with him."

Seidel spoke with Snook in his cell as the professor ate breakfast and then returned to Chester and said Snook had no intention of confessing.

Seidel said he wanted to be present from that point on when his client was questioned. Chester agreed but said if Seidel "uttered one sound he would throw him out."

About 7:00 a.m., the professor was returned to the detective bureau, where the questioning began again. Snook was still logy from the earlier interrogation and was slow to answer questions. When Seidel chastised Chester for asking questions too quickly, Chester turned on him and ordered him out of the room. Inexplicably, Seidel grabbed his hat and coat and left.

At one point, Snook refused to answer any more questions, and Chester lost his temper. He stood in front of the seated professor and proceeded to slap his face back and forth with both hands until Chief French pulled him away. The five slaps left red marks on both cheeks. Snook then agreed to continue with the questioning. Shortly after, the stenographer was called into the room to take a statement.

At noon Thursday, one week to the day after Theora was slain, Prosecutor Chester met with the press and triumphantly announced that Dr. James Howard Snook had signed a written confession admitting to the premeditated murder of Theora Hix.

Whether the confession was worth the paper it was written on remained to be seen.

Part II
CONFESSION

"The Friendship Continued in a Very Intimate Way..."

It took less than a month from the time that Dr. Snook and Theora Hix first met each other in 1926 for the pair to become lovers. Snook was vulnerable when they met and not inclined to make smart choices. The past few years had not been good for him. His son had died; his wife, Helen, was focused on their infant daughter, and he felt he had nothing left to achieve professionally or as a marksman. The future loomed ahead as an endless string of department meetings, lonely dinners, long nights and tedious weekends tending the flowers in his garden. The couple was cordial, but they spent more time apart than together, eating their meals separately, and had taken to sleeping in different bedrooms. Snook had his work, and Helen had her daughter and her church work.

Helen noticed that he had become distant from her in the last few years, and even though she claimed ignorance of his affair with Theora, in 1928 she consulted an attorney about obtaining a divorce. She never moved forward with the process. In her only interview during the period around the murder, she told *Dispatch* reporter Anne Schatenstein that her husband had withdrawn from her. "He loved to be with me. We went out often together. He wanted to have friends in our home, mutual friends. We were happy, really happy," she said. "But things changed. I lost him—little by little and more and more. It was gradually, just gradually. I knew not how or why. I did not question."

Helen described her husband as restless and unable to sit still or read for any length of time. Snook's mother also saw a change for the worse. "He was

The OSU Veterinary School class featuring Dr. Snook's portrait. Snook was a highly regarded professor with a national reputation.

not the same [after the death of their son]," she testified. "He did not seem to take an interest in anything. His mind seemed to be somewhere else."

Snook's work was also suffering, and he had been called on the carpet for behavioral issues at the vet school, including "keeping company with a woman other than his wife," according to Dean White of the vet school. White did not say whether the other woman was Theora. "The reason [he was confronted] at that time was I felt that he was slipping in his work," White said. "I wasn't complaining so much because he was keeping company with women. That was only incidental."

Their relationship started out innocently enough. Theora joined the steno pool at the vet school in the summer between her junior and senior years, and as Snook was a prolific writer, they spent a great deal of time together. After he gave Theora and a friend a ride on a rainy day, they grew closer. A week after that first ride, Theora and Snook were leaving the office at the same time when she remarked that it was such a nice day it seemed a shame

to go right home. Snook mentioned that he had driven his Ford to work and invited Theora to take a drive with him in the country. On the ride they discussed a number of subjects, including marriage and relationships.

"After about the third week…we discussed companionate marriage and sex relations and books on sex and to that extent," Snook said later. "Each one seemed to understand that the other knew something about it, and there was a mutual understanding there of that nature to talk about things of that kind."

When Snook and Theora met, a controversial new philosophy of marriage was emerging. *Companionate Marriage* was a book written by Judge Ben Barr Lindsey, a progressive Colorado jurist who is best known for establishing the nation's first juvenile court system and for championing the cause of child protection. Lindsey's book addressed the changes in American values and asserted that there was nothing wrong with a marriage where sexual attraction was a primary concern of the husband and wife.

"Such marriages embraced democratic family organization, produced fewer children, and prioritized couples' mutual emotional and sexual needs," writes Rebecca L. Davis in a 2008 article in the *Journal of American History*. "[Lindsey] advocated providing couples with birth control and access to easy divorce, so that marriage might become a modern institution, free from moral hypocrisy." To others, "companionate marriage" meant free love, the destruction of the American family and even "Bolshevism," Davis writes.

In an advice column from 1929, syndicated columnist Dorothy Dix—the forerunner to Ann Landers and Dear Abby—addressed the subject of companionate marriage:

> *Dear Miss Dix—Do you think that companionate marriage makes a legal prostitute of a girl? Will a marriage based on thrills alone hold up under the trying conditions of everyday life? Will a man and woman who have got in the habit of swapping wives whenever they want a change ever be willing to settle down to a steady job of being married and burdened with children?*
>
> *We are two young girls, but when we get married we want a good old-fashioned wedding with all the knots tied as tightly as possible.*
> *SEEKERS.*
>
> *Answer:*
> *And right you are, girls. The companionate marriage is an alluring proposition to a man, but it is a losing bargain for a woman, and any girl*

who would enter into one is certainly a fit candidate for the fool killer to deal with.

It gives the man all the pleasures and perquisites of matrimony with none of its drawbacks. He has the companionship and services of a wife without having to support her, and when he gets tired of her he can chuck her out of the door or get up and leave her as casually as he would discard an old pair of shoes.

A discussion of companionate marriage with a modern young woman must have been titillating for the middle-aged professor, and it quickly led to even more intimate conversations.

In one conversation, Theora mentioned that she had recently "lost her companion" and that she was concerned about catching a venereal disease from casual relations with other students her age. Theora confirmed to Snook what others surmised. "She didn't go around much with students," Snook said. "It was along about that time she said that she preferred someone older, who really knew something. I asked her directly what she knew about it, meaning sexual affairs, and she told me she knew more about it than I did, and that I should read some books on that."

A few days later, Snook said he presented Theora with a book titled *The Art of Love*—"quite a rare book and not always sold, I believe, and she told me that she had already read that book."

From that point, it was a short trip to the bedroom, and Theora and Snook began their affair. It was an affair based on pleasure and nothing deeper, Snook told reporters. "Our friendship developed rapidly and our auto rides increased in frequency," Snook said. "I took a very strong liking to the girl but I do want it understood that ours was not a silly little love affair. I still love my wife and baby and want to see them happy."

From early autumn 1926 until June 1927, Theora and Snook engaged in sex at least once each week, renting rooms by the day or making love outdoors on a blanket he kept in his car for that purpose. The couple took a four-day trip to Camp Perry along the Lake Erie shoreline, where Snook took part in a shooting competition shortly before Theora decided to move to New York City to continue her education there.

While Theora was living in New York, Marion Meyers visited her, staying for a week. They rented a hotel room because Theora's rooming house prohibited unescorted male visitors in the women's suites. Theora's time back east was short, and she returned to Columbus in the fall of 1927, resuming her relationship with Snook.

In early 1928, Snook underwent an operation to correct a deviated septum and suffered some complications. During his convalescence, he did not see Theora for several weeks, and she began seeing Meyers again. It was in February of that year that they were caught *en flagrante* and fined by the justice of the peace. Theora did not conceal her relationships from each of her lovers, and Snook, at least, was agreeable.

Eventually, Theora's fling with Meyers ended for good. Snook taught Theora how to shoot pistols and rifles, and she eventually became quite a good shot. After she developed some skills, Snook presented her with a .41-caliber double-barrel Derringer pistol for protection. Theora began to carry it in her purse, although Ohio law did not allow for private citizens to carry concealed handguns.

"She Considered It Her Right to Dictate My Movements..."

But by early June 1929, Snook was chafing under Theora's constant criticism and demands. He wondered where this relationship of convenience was heading. He was planning on taking some time the next week for a short vacation and had promised to take his wife and baby to see his mother. A few days away from Theora would do the trick, he thought. As the poet wrote, distance in a love affair can be like wind with fire: it extinguishes the small and fans the great. In any event, being with her twice a week was beginning to get tiresome, and the situation was likely to worsen in the short run. With her out of class all summer, she would be bored and want even more of his attention.

Things had been going along in this manner for several months. The affair's excitement had worn off, and they were more like two conspirators bound together forever by a shared but now regretted crime. More often than not they fought.

On Sunday, June 9, 1929, the professor was changing into his golf attire at the Scioto Country Club. Deciding to play a solo round of afternoon golf in an effort to clear his head, he had already called for a caddy. At the next locker over, Charlie Druggan, an attorney in Columbus, was also preparing for a golf match and asked Snook to join him and another man. Snook politely agreed.

The men were waiting their turn at the first tee when a boy came out of the clubhouse and told Snook he had a telephone message. Snook called the number and got no answer. He asked the attendant what the call had

The Scioto Country Club where Theora and Snook went shortly before her murder.

been about. "He said someone called me and said it was important," Snook testified at his trial. "I called back again and then told him to take the message and say that I would be in at 5 o'clock."

Snook put the call out of his mind, and the men began to play. At the fifth hole, Druggan's drive sliced off the fairway, and the men were looking for the lost ball when Theora appeared. She looked upset and "had a peculiar look in her eye," Snook said.

Theora's mouth was set, and her lips were pursed so tight they trembled. Snook knew she was angry—he had seen this look frequently of late. "What's this about?" he asked in a quiet voice.

"I put in two calls for you!" Theora let loose.

Snook looked around. They were standing about fifteen yards from where Charlie Druggan had finally located his ball, and the attorney was about to take his second shot.

"Keep your voice down," Snook said. "As a matter of courtesy, wait until Mr. Druggan shoots."

"I don't give a damn whether he shoots or not!" Theora said, stamping a foot. "I want you to go with me."

Snook explained that he could not leave his fellow golfers in the middle of a match, much less at the fifth hole, where they were about as far from the clubhouse as could be.

"Besides," he said. "I would rather play on."

"I want you to leave NOW!"

"Walk with me until the ninth hole," Snook said, exasperated. "It's a more courteous way to quit playing than just to walk off."

"No," Theora replied, crossing her arms across her chest.

"You won't wait until I play nine holes?" he asked.

"No, I want you to go with me right now," Theora said through gritted teeth, her voice frosty. "I mean it."

Snook looked around, shrugged and picked up his ball. He made his apologies to his surprised friends and slinked back along the links to the clubhouse, his head down and his shoulders hunched, looking much like a chastened young boy whose playtime has ended because his mother called him inside to take a bath.

Theora's behavior was becoming so erratic and unpredictable that Snook said he started keeping notes "of the things she did to show her that she would do things like that and then deny them later."

The behavior Snook attributed to Theora is symptomatic of drug or alcohol addiction, but aside from the drugs found in her system during the autopsy and Snook's inconsistent claims about her drug habit, there is no corroborating evidence that Theora was a regular user.

Snook waffled during his interrogation between saying Theora pressed him for drugs and denying that he had ever seen her so much as smoke a cigarette. Snook undoubtedly had unlimited access to alcohol despite the Prohibition laws against it because of his position at the vet school, but the subject of drinking never came up during his questioning. For obvious reasons, none of Theora's casual acquaintances would cop to indulging in booze with Theora, and Meyers denied ever seeing Theora drink or use any illegal drugs. Police did not find any drug paraphernalia among Theora's belongings, although the purse she had with her the night she died was never recovered. Nor did they find any incriminating evidence of drug use at the Snook home; beyond the Spanish fly and a bottle of ether that Snook claimed he used as cleaning solvent, there was nothing in Snook's office related to drugs.

However, Dean White told police of one incident when Snook was disciplined for supplying morphine to a friend's wife who was obviously a drug addict. She approached him and complained of gallbladder pain, and he gave her several morphine tablets. Within a couple of days she returned, saying that she had "lost" the pills. He replaced them without question. Before long she returned, saying the pills had "accidentally" fallen down

the drain. He admonished her to be more careful and gave her more pills. Shortly after the woman was hospitalized in a drug-induced stupor, her husband confronted Snook, and he ceased providing the woman with drugs. Snook told authorities that the morphine had been given to him by a fellow veterinarian who no longer practiced.

"I'll Kill Your Wife and Your Baby!"

On Thursday, June 13, Theora left the Ohio State University hospital switchboard and headed out to Neil Avenue, looking for Dr. Snook. Earlier in the day, she had called Snook and arranged to meet him about 8:00 p.m. Although each was in the area of their agreed-upon meeting place, they failed to connect. As a result, Theora took her cab ride with Earl Nickels, and Snook went to the state market to buy some food for his "lunch," which he normally ate when he returned home late in the evening. He parked his dark blue Ford coupe on High Street near the corner of Twelfth Avenue by the OSU Student Union and walked to a mailbox to deposit some letters. As he started back toward his car, he saw Theora approaching it from the opposite direction.

They said little to each other as they drove north on High Street, away from the campus. The air was close and damp; it was going to rain any moment, and that only seemed to add to the tense atmosphere in the car.

"Did you eat anything?" Theora asked.

"No."

"I did. I left a bit early and had a bite to eat and I brought you a sandwich," Theora said, handing a roast beef sandwich wrapped in white butcher paper.

"Do you want to go to the apartment?" Snook asked. "If we're going to give it up, we might as well for one last time."

"Not particularly," Theora replied. "Let's go out somewhere."

"Then give me your key before I forget," Snook said. Theora dug through her handbag and extracted a key ring. She pulled a key off the chain and gave it to him.

They turned west on Lane Avenue and headed toward the Scioto Country Club, where Snook had left a pair of shooting glasses he needed for the next day.

As they drove away from the country club, the streetlights of Upper Arlington began to illuminate behind them. Snook and Theora continued west on Lane, watching the last rays reflect off the bottom of the ominously dark clouds as the sun slipped below the horizon in front of them. It was near the height of summer, and the days were long in the Midwest. Once the sun went down, darkness came upon the couple quickly. The waxing quarter moon was obscured by the heavy, low-hanging clouds that would soon drench the area in rain.

"I'm going out of town this weekend," he said. "I'm going to Lebanon."

"I don't want you to go," Theora replied petulantly.

"I'm sorry, I promised Mother that I would come and that I would bring my wife and the baby."

The mention of Helen Snook sent Theora into a rage, and the young woman cursed her rival. Snook had expected a scene like this. More than once, Theora had demanded that he not go on a trip, and outings involving his family were particularly galling to her. Snook said nothing as Theora sank back into the upholstery, her arms crossed and her chin quivering. When she was in a mood like this, there was nothing he could do.

The professor was tired of Theora's sulking and started to discuss shooting. They were on the far west outskirts of the city now, not far from the New York Central railroad shooting range on McKinley Avenue. Snook had been there earlier in the day watching a shooting match between the Columbus Division of Police and a team from New York City. He was no stranger to the range or the police department that used it for practice. He had been part of a committee of experts who helped the department select ammunition for the new Colt revolvers the officers now carried.

In an effort to distract Theora and perhaps bring her out of her funk, Snook pulled into the range and drove some distance into the field. Because Theora had enjoyed shooting with him, and had even become something of a sharpshooter herself, he assumed that a bit of technical talk of firearms and shooting might brighten her mood. Instead, the girl remained silent and simply looked out the window.

Suddenly, she turned toward Snook.

"Damn you!" she spit at him. "I'll kill your wife and your baby!"

"Now," Snook started to say, trying to calm her.

"I'll kill you, too!"

The Professor and the Coed

The Columbus Division of Police Ordnance Section now uses the shooting range.

The expression in Theora's eyes told Snook that she might be serious. After all, she had been acting strangely and unpredictable lately. Snook watched as Theora turned to her right and picked up her purse. She opened the clasp, and he immediately thought of the Derringer he gave her some time ago and which he had seen in her purse before. Snook thought she was going for the gun.

Theora reached for the door handle, and without thinking, Snook reached out his right hand and grabbed a ball-peen hammer he kept in a toolbox on the back shelf of the coupe. He raised it and hit Theora on the back of her head with the side of the hammer. She reeled from the blow but continued to try to get out of the car with her purse.

"Damn you," she cried as he struck her again, this time on the forehead with the hammer. He meant the blows to stun her, but they did not seem to have any effect.

Theora managed to get the door open and stepped from the car. Snook slid across the seat and followed her. The angry woman tried to slam the door on Snook, but her own hand was in the way, and she only succeeded in injuring herself. Theora staggered back a few feet and reached into her purse with her injured hand, drawing forth a handkerchief as Snook slid out of the car.

Freed from the confines of the tiny coupe, Snook extended his arm and brought the hammer down on Theora's head with a crushing blow. She fell to the ground.

"Damn you." This time it came out as almost a moan, and then Theora slipped into unconsciousness.

Snook found himself sitting on the passenger-side running board of his car looking at the inert form of his lover. She was still alive but was in obvious distress and not likely to survive much longer. He did not want to see her suffer, so he stood up, walked over to her, took out his two-blade pocketknife and calmly sliced Theora's jugular vein and carotid artery. It was a clean cut, one any surgeon would be proud of.

In shock himself, but glad to be alive, Snook picked up Theora's purse and threw it into the car. He looked inside for the Derringer and was horrified when he learned it was not there. Theora could not have killed him after all. He did not notice that the key ring that Theora had opened not an hour before had fallen from her purse and that the remaining keys were scattered amid the weeds.

It was shortly before 9:30 p.m., and he was afraid that someone might come along and find him, so he ran around to the driver's side and jumped in. The Ford roared to life, and he sped away, leaving Theora's dying body behind. Somewhere along the way, he realized that he still had her purse, and he tossed it over a bridge into the Scioto River as he headed home.

The drive to his Tenth Avenue home was a blur, but he noticed it was about 11:00 p.m. when he walked into the dark house. He hastily washed the blood from the knife and hammer and went into the kitchen, browned some hamburger and tried to make a sandwich.

"Is that you?" Helen called from the upstairs.

He said nothing, and Helen came down the steps in her nightgown. The kitchen was dark, and she did not notice the blood on his suit. Snook ate his sandwich in silence and then went to his room, where he began packing for his upcoming trip. Then he lay in bed and tried to sleep without success.

On Friday morning, he took his suit and some other clothes to the dry cleaner and dropped his car off with Walker, the veterinary school custodian, with whom he had an arrangement to have the vehicle washed. Walker noted that the coupe was quite dirty, as the rain the previous night had turned the accumulated road dust to mud.

Once the car was cleaned, Snook headed to the Hubbard Avenue apartment and cleaned out the few items remaining there. He was in such a rush that he left one of Theora's hats behind. He bid farewell to Mrs.

Smalley and hoped he had covered his tracks well enough. Then he went to the university and dropped off some of the items from the apartment in his office before returning home and lighting the fire in the incinerator.

Dr. and Mrs. Snook read in the Friday Evening *Dispatch* of the discovery of the body of a murdered young woman, but the story did not prompt any conversation between the husband and wife until the *Citizen* published the victim's name that Saturday morning. Snook mentioned to his wife that he knew Theora Hix because she worked in the steno pool in his department.

The professor had just mentioned how tragic the murder was when someone knocked at his front door. It was a detective and a reporter from the Columbus *Citizen*.

"A Voluntary Statement"

The text of the confession signed by Dr. James Snook:

> *I met Theora Hix about three years ago. The friendship continued in a very intimate way ever since, inasmuch as she was a very good companion. I have been living with my wife during this three-year period and regard my wife very highly and respect her very much as a wife, but she lacked some of the companionship afforded by Miss Hix.*
>
> *During the three years that I knew Miss Hix, I did assist her in many ways toward an education but I found out it wasn't as appreciated as I thought it should be.*
>
> *Our association was not a love affair in any sense of the word, but in time Miss Hix developed a more determined attitude in regard to dictating my movements and the final culmination of this occurred on the 13th of June of this year when I met Miss Hix at the corner of Twelfth Avenue and High Street in the City of Columbus, Ohio, when we both got into my Ford Coupe and proceeded to drive to Lane Avenue and then west to the Fisher Road and to the Columbus Rifle Range of the New York Central Railroad Co., during which she remonstrated with me against leaving the city with my family for the week-end as I had previously planned to do.*
>
> *She threatened that if I did go that she would take the life of my wife and baby. During this quarrel she grabbed for the purse in which she sometimes kept a .41-caliber Derringer which I had given her.*

In the struggle she was hit on the head with a hammer with the intent to stun her. She continued desperately and an increased number of blows of increasing force was necessary to stop her. Realizing then that her skull was fractured and to relieve her suffering, I severed her jugular with my pocket knife.

I then proceeded to pick up the things that had been scattered during the struggle and hurriedly left the scene of the struggle, leaving her body at that point. The instrument which I used to quiet her was a hammer which was laying on the back seat of the Ford.

After leaving the rifle range I then proceeded to go home, tossing the purse from the Quarry Bridge into the Scioto River on my way. After the struggle I discovered the gun was not in the purse.

Question: Now, Doctor, I want to ask you just a couple of questions. Are you making this statement voluntarily?

Answer: Yes, sir.

Q: Nobody threatened you or promised you anything for the making of this statement, have they?

A: No, sir.

Q: And everything that you have said in this statement is the truth, is it?

A: Yes, sir.

[Signed J.H. Snook.]

Part III
JUSTICE

Public Opinion

Snook lay in his county jail cell in a white nightshirt, exhausted. It was around midnight, about twelve hours after he had signed the confession Chester put in front of him. His mind was reeling from the events of the past thirty-six hours, and everything that had occurred since midnight Thursday was a blur. He vaguely recalled meeting with John Seidel around breakfast time Thursday morning but had no memory of what they talked about. He did remember someone telling him that his wife had been notified of his confession, but who told him and when was impossible to recall.

He felt as if he was awakening from a drugged sleep.

"Snook! The newspapermen are here." It was the deep baritone voice of Sheriff Harry Paul.

Snook looked up blankly and saw the sheriff standing with several men staring at him through the bars and remembered the "agreement" he had made with Chester. The prosecutor wanted him to talk to the press and agreed to give him until Friday morning to "gather his thoughts." Snook did not realize that Friday morning meant midnight.

The professor recognized one of the men as the reporter who had tailed Detective Van Skaik to his home the day he was arrested. He did not know the man's name, however. Only one other man looked like a reporter; the rest were obviously cops or lawyers who wanted to watch the interview.

In the back of his mind, Snook knew that talking to these reporters was a bad idea, but at the time he was overcome with guilt, regret and fatigue that made clear thinking impossible. His ego still allowed him to believe he

could manipulate this interview to his advantage. He was not going to tell everything he told the cops, but he wanted people to know that Chester beat the so-called confession out of him.

The man Snook recognized—James E. Fusco—was the first to speak. "Dr. Snook, I'm Fusco, I'm with the *Citizen*," he said. "You remember we had breakfast together last week?"

The other reporter introduced himself as William C. Howells representing the *Plain Dealer* of Cleveland. The reporters then listened as Snook told a story similar to the one in his written confession. Fusco asked him why he waited so long to admit his crime.

"I hadn't made up my mind whether to keep my mouth shut and protect myself or confess," Snook replied. "I just couldn't bring myself to admit the deed."

"Why was that?"

"If I told everything I would involve the girl and I didn't want to do that," he said. "Now, I don't want the public to think that I am hiding behind a woman's skirts because I place some of the blame on her."

"What will you do now?" Howells asked. "Will you plead guilty?"

"What else can I do?" Snook replied and then tried to retract his statement. "Wait don't use that. That doesn't depend on me. I'll have to talk to my lawyers."

Snook was regaining some of his strength, and the cool demeanor that was the bedrock of his character was returning. Like a man used to being in control during a stressful situation, he began to excoriate Chester. "Chester slapped me during the grilling and I felt like hitting him back," Snook said. "Though I am glad now that I didn't. I wanted to kick him."

The idea that the prosecutor had extracted the confession through force did not have the impact Snook had hoped for. In fact, the stories filed by Fusco and Howells and the subsequent rewrites by the wire services buried the slaps toward the bottom of the articles as if it was a given that violence was a normal part of an interrogation. In many versions of the stories that ran in more distant newspapers, Chester's assault was never mentioned.

Snook tried again. "They got me wrong what they thought I wanted to confess after that all-night grilling," he said. "They wanted me to tell about the crime and they wouldn't let me go until I told it. That's why I told them I wanted to see my lawyer. I wanted to get away from them. I was worn out."

When Ricketts read the articles, he was livid but saw a way to win a major victory in a war that would increasingly be played out in the press. "This party of reporters at the jail to interview Dr. Snook was organized by

the prosecutor's office because they're afraid of the validity of the alleged written confession," he told reporters following up on the stories in the *Plain Dealer* and *Citizen*.

The cops who conducted the interrogation also had a chance to tell their version of the ordeal and were at the same time charitable to Snook and contemptuous.

"The ousted university professor, according to police, parried questions throughout the long hours and seemed to relish the ordeal, placing his questioners on the defense on numerous occasions," the *Dispatch* reported later. "The man refused to break on vague questions and would only talk when he felt sure the police knew the correct answers to the questions they were asking."

For most of the night, Snook was sharp and "on alert," at first giving as good as he got. He often gave long, rambling answers to simple questions that led the investigators away from the point they were trying to establish, they said. "Every other answer to one of our questions was a question in an endeavor to confuse us," Shellenbarger said.

Phillips played the "Bad Cop" part and recalled the ordeal for reporters.

"We mocked him, laughed at him, we were sarcastic, we patted him on the back, we cajoled him, possibly insulted him," Phillips said. "Until shortly before dawn we saw that he was going to break and soon admit his guilt."

When Chester pointed out that the blood in the coupe had been conclusively determined to be human, Snook did not lose his cool; instead, he was saved by his ignorance of the advances in hematology that now allowed scientists to determine the source of a bloodstain.

"Let's talk about something else," he said confidently. "I've been in this game too long—you can't tell me that you can take little spots like those and tell if they came from an animal or a human."

The police made no bones about the treatment Snook received. "I used him rather roughly, as far as language was concerned," Lavely said. "I called him a dirty dog and cursed him because I thought I could make him tell something."

The *Dispatch*, stung by the scoop given to the *Citizen* and the *Plain Dealer*, relied solely on the word of the police and undoubtedly printed quotes attributed to Snook that the professor never uttered. For example, the police told the *Dispatch* reporter that Snook complained that he was not allowed to see Theora's corpse the way Meyers had been. "I want to see if she has the same sneer on her face as she did when she died," the *Dispatch* said Snook told police.

Chief French was honest with his prisoner when he told Snook that the consensus on the street was that the professor had murdered Theora in cold

blood. While the general public was not so up in arms at the crime that there was talk of vigilantism, Snook's supporters were few in number. Helen Snook had taken to her bed when she learned of her husband's confession and remained a recluse until shortly before the trial, when she granted her only interview to *Dispatch* reporter Anne Schatenstein. She continued to support her husband and made sure he was as comfortable as possible during his confinement, but the press had to accept the word of Ricketts and Seidel that she was standing by him.

Helen's parents, however, were not so supportive. Tracked down by reporters during a lull in the action in Columbus, Helen's father, James Marple, said his son-in-law was "right where he belonged."

Melvin Hix was quite outspoken when he learned of Snook's confession. Grief had turned into anger, and Hix wanted vengeance. The newspapers, working to make sure the Snook story "had legs"—in other words was still interesting to readers—were happy to provide him with a forum in the weeks leading up to the trial.

"I don't believe what he says about my girl. He is the man who did all he could to break down her moral reserve. No punishment is too severe," Hix said. "He was a man of education and position—the type that young, inexperienced girls look up to. He influenced my girl. She did not know he was the type he is—shrewd and calculating. She was putty in his hands and he moulded her to suit his fancy."

The same Western Union source who leaked the telegrams from Marion Meyers's fiancée also provided the *Dispatch* with a message sent to John Chester by his old Sunday school teacher, now the pastor at the First Methodist Episcopal Church in Charleston, Illinois. The tone of the message made it clear that the Reverend Harry B. Lewis had an Old Testament view toward sin. "I hope that you may be able to mete out to him the punishment he so manifestly deserves," he wrote.

The *Dispatch* editorial page continually weighed in on the case. A week before jury selection was to begin, the paper printed a cartoon featuring a drooling hyena standing over a skull and pile of bones at the mouth of a cave labeled "Temporary Insanity." The cartoon's title was "The Refuge."

The Circus Comes to Town

But Theora Hix's murder was no longer a local or even a regional story. The 1920s were a time of great advances in newspaper technology, and not only was it easier to get seasoned reporters to the scene of a big news event and get their stories out, but there was also money to be made in selling those stories to smaller papers that wanted to cover the big stories but did not have the wherewithal. Part of the scheme was to cultivate star reporters whose bylined stories were distributed across the country via the news syndicates like the Associated Press, the United Press, International Press Syndicate and the proprietary syndicates operated by publishers like Hearst, Scripps and Pulitzer. Once the story of Snook's confession hit the news wires, these reporters and their syndicates converged on Columbus in hopes of proclaiming the next "Trial of the Century."

The Roaring Twenties had been a busy time for reporters like James L. Kilgallen of Hearst's syndicate and Kenneth Tooil, who just happened to be a nationally syndicated feature writer employed by the *Dispatch*. In just the first third of the twentieth century—really in just a ten-year span of that first third—these stars and others like Ben Hecht, Arthur Brisbane West, Haywood Broun, Morris De Haven Tracy and Damon Runyon had covered at least three other "Trials of the Century," a title that the press was considering for what was now known nationally as the "Snook-Hix Case." The number of trials in the also-ran category covered by them was too many to count, such was the nation's hunger for sensational news.

Criteria for winning the Trial of the Century title are subjective, beyond the necessary murder charge, of course, but at the time of the Snook-Hix Case, sex was an essential component. A case involving a love triangle was always a contender, as was any trial where the defendant was female, a member of the clergy or from the upper class. Blunt objects, rope or poison always trumped crimes involving knives, and the use of a gun (unless there was a struggle for it during the commission of the crime, its source was a mystery or it was wielded by the woman who later claimed self-defense) was almost cause for disqualification. Another important requisite was how accommodating the judge was for the press and the eloquence and liveliness of the lawyers. Not directly part of the criteria, but important nonetheless, were the creature comforts and amenities afforded to the reporters covering the trial. Cities with good hotels and easy access to bootleg liquor were always appreciated.

The first "Trial of the Century" covered by Kilgallen and Tooil was the 1924 murder of Bobby Franks by two young scions of Chicago society, Nathan Leopold and Richard Loeb. The Leopold and Loeb trial met the criteria because it involved a pair of upper-class, intelligent young men who kidnapped Franks at random and killed him solely to see if they could pull off the perfect crime. The lead defense attorney in the case was legendary lawyer Clarence Darrow. Leopold and Loeb were facing the death penalty, and everyone expected Darrow to mount an insanity defense, as the evidence against the pair was overwhelming. Instead, Darrow had them plead guilty and used the sentencing hearing as a death-penalty referendum. Leopold and Loeb were spared, thanks to what is widely considered to be Darrow's finest argument.

Kilgallen's reporting of the event for the Hearst syndicate helped make him a household name, and he was the first reporter to track down Al Capone in his Palm Beach, Florida villa after the 1929 St. Valentine's Day Massacre. Capone denied any involvement in the crime, and Kilgallen reported that the gangster told him, "They blame me for everything from a small fight in Chicago to a riot in Timbuktu." Tooil was familiar to Columbus readers because he was a star staff reporter for the *Dispatch* who roamed the country in search of the big story.

After the Leopold and Loeb trial, Kilgallen and Tooil headed to New Jersey to cover a trial connected to the mysterious killings of an Episcopal minister, the Reverend Edward W. Hall, and his mistress, Eleanor Reinhardt Mills, a member of the choir at Hall's church. The couple was killed on a lover's lane in New Brunswick, and the case remained stagnant until a trial in 1926 that resulted in the acquittal of Hall's wife and her two brothers. That case technically remains unsolved.

Scandal and Murder at the Ohio State University

Kilgallen was one of the dozens of reporters who covered the murder trial of Judd Gray and his lover, Ruth Snyder, in 1927. Snyder convinced Gray, a weak-willed alcoholic, to beat her husband to death with a sash weight normally used to help open and close heavy windows. The case is perhaps best known for the iconic photograph of Ruth Snyder dying in the Sing Sing electric chair, taken for the New York *Daily News* by a photographer with a camera strapped to his ankle.

He had covered lesser trials in Ohio, as well. Just a year before the Snook-Hix Case, Kilgallen scored a major scoop when he interviewed Velma West of Perry, Ohio, who beat her wealthy horticulturist husband to death with a hammer when he wanted her to stay home rather than go to a party. Kilgallen got West to admit to having written erotic letters to a female friend and dubbed the flapper "the nightclub girl in a curfew town." But West put her own interests ahead of a chance for a brief moment in the limelight when she opted to avoid a likely death sentence and pleaded guilty to second-degree murder in return for a life term. (Had Velma West gone to trial, Snook's lawyers would have been paying close attention. She had been planning to use a temporary insanity defense similar to the one Snook would try.)

Shortly before the start of jury selection in the Snook-Hix Case, Kilgallen had an exclusive interview with Snook where he rejected the notion that the doctor was just a monster. Instead, in a manner quite distinct from the sensationalist prose of his cohorts in the press, he painted a word portrait of Snook as the protagonist in a classic Greek tragedy—a man brought to his doom by his own hubris. "I never thought my affair with Miss Hix would lead to this. How did I come to do this?" Snook wondered. "I keenly feel the disgrace this has brought upon my wife and my baby. Everything has come down on me, crushing me."

The public's interest in the story was not limited to the written word. Honorable Henry J. Scarlett, the chief judge of the Franklin County Court of Common Pleas, agreed to allow a few cameras in the courtroom for short periods—the technology of the time made subtle, unposed inside photographs impossible—and noted artists like Dudley Fisher and *Dispatch* caricaturist Milton Caniff were on hand each day to provide vivid illustrations of everything from the courtroom scene to portraits of each juror. It is not an exaggeration to say that his work in the Snook case helped make Caniff. When the Depression prompted layoffs at the *Dispatch*, Caniff had no trouble moving up to the top-tier papers in New York City, where he created *Terry and the Pirates* in 1934 for the *Daily News* syndicate.

The press not only fed the public's insatiable need for news of the trial, but it also criticized that same curiosity. *Courtesy of the* Columbus Dispatch.

The Snook-Hix Case became moral fodder for the national columnists to chew on as well, and neither Snook nor Theora emerged unscathed. One writer asserted that the real victim in the case was not Theora but Helen Snook: "A husband who will deceive a wife was the thing at stake here to women, rather than a man who killed a woman. Theora Hix, the dead co-ed, is not here to be avenged so much as Mrs. James Snook who did not know about that 'love-nest.'"

The press unashamedly played the hypocrite during the Snook-Hix Case. On the front page, it pandered to the readers, supplying details of the most mundane sort, while the persnickety editorial pages chastised the public for its lurid fascination with the sordid case. The papers happily interwove fact, fiction, commentary, satire and pure fluff, leaving readers to decipher which was which.

Strategy and Tactics

When Snook was returned to his cell after signing the confession, he was met by Ricketts, who found his client "absolutely incoherent." Ricketts also noted the red marks on Snook's cheeks left by the slaps administered by Chester. The lawyer had no doubt that the confession would not stand up in court. Even in the laissez-faire attitude toward prisoner interrogations at the time, a sixteen-hour grilling involving a physical beating by the prosecutor was coercion in his book, and he presumed the judge would feel the same.

The confession itself was suspect and did not sound like it had been dictated by Snook. It was too complete and handed Chester a first-degree murder charge on a platter. Before Snook "dictated" his confession, Chester said he explained the four levels of murder: first-degree murder, second-degree murder and two levels of manslaughter. The difference between first- and second-degree murder involves the addition of "prior calculation or design" to the mental state of acting "purposely." The concept of prior calculation requires the murder to engage in some sort of plan or reasoning before setting out to kill, and when Snook signed a confession saying he slashed Theora's throat because he did not want her to suffer, he was certainly admitting to premeditation.

"If he had made this confession voluntarily, would he have told Chester the very things that would put him in the electric chair?" Ricketts later said he asked himself after reading the confession. "The four degrees of murder were explained to him and he picked the highest charge to admit to?"

The Professor and the Coed

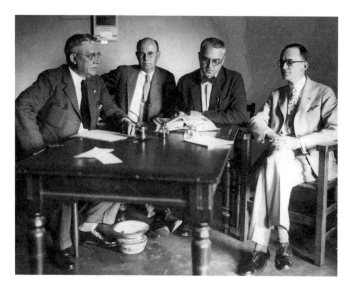

Dr. Snook and his defense team. *Left to right*: E.O. Ricketts, Dr. Snook, John Seidel, Max Seyfert. *Courtesy of the* Columbus Dispatch.

Still, the attorney knew better than to bet all his chips on that one play of the cards and immediately began to formulate a plan to defend his client. He had three choices if he did not succeed in having the confession thrown out. The first he dismissed right away: portray the confession as a false admission of guilt and point the finger at someone else. Even without the confession, what he knew of the prosecution's case was strong, and he was not willing to gamble Snook's life on being able to break the chain of circumstantial evidence Chester had forged.

The second option was self-defense, which Ricketts felt was a better option. He had spoken candidly with his client before Snook confessed, and he knew there was a great deal that had not been included in the confession. Based on what he had been told really prompted Snook to reach for the hammer, Ricketts felt confident that most men would have acted in the same fashion. If that was not enough to raise a self-defense argument, they could probably sell the jury on the idea that Snook was afraid Theora was going to hurt his wife and child.

The third prong of the defense, Ricketts thought, would be to use insanity, but that would be difficult. Although the idea of insanity as a defense to a crime had been around for centuries, juries were reluctant to accept the idea that a defendant was too crazy as a result of a mental disease or defect to know what he was doing when he committed the crime, or if he did know what he was doing, that he was seized with an irresistible impulse and unable to stop himself. Ordinary people, particularly the types who would be sitting

in judgment of James Snook, found it hard to believe that anyone could be so out of touch with reality that he did not know he was committing murder. Regardless, Ricketts knew of the drug use and Snook's state of mind during the last few months, and with the help of a couple of cooperative alienists, perhaps he could save his client from the electric chair.

Both the self-defense and insanity arguments were dangerous courses to navigate because in each situation, part of the defense involved acknowledging the basic fact that the defendant had wielded the instrument of death. If the second half of the defense failed, the jury was left with the fact that the defendant had admitted having a role in the death of the victim.

For insanity pleas, Ohio used a bifurcated system in which there were actually two separate trials. In the first, the question of guilt was determined, but as this necessitated the defense to admit certain facts involving the defendant's role in the crime, the prosecution's job was comparatively easy. In the second half, the roles of prosecution and defense were essentially reversed. It was not up to the state to prove that Snook was sane; it was Ricketts's job to prove that his client was crazy.

Trials in which self-defense was an issue still required the state to prove beyond a reasonable doubt that the defendant had committed the crime, but at the same time, the defense had to prove to a lower standard than reasonable doubt that the defendant was in fear for his life and was acting sensibly when he used deadly force to protect himself. The state could destroy a self-defense argument merely by showing that Snook was responsible for starting the quarrel or did not take steps to extricate himself before resorting to deadly force.

Ricketts and Seidel also decided to challenge the competency of the coroner, Murphy, and his conclusion that Theora was alive when Snook cut her throat. It was a long shot, but if they could establish that one of the hammer blows delivered in the heat of passion had been the fatal act, then the question of premeditation was in doubt. The defense team began looking for experts who would help punch holes in the coroner's report.

What the defense team could not do was overtly blame Theora for her own death. Ricketts and Seidel knew they would have to walk a fine line in making sure the jurors knew what kind of a woman she was. To do this, they would have to play up the sex and drug angles of the case. Snook was finished in Columbus anyway, they knew, so destroying what was left of his character was not going to be much of an issue. It was a small cost to pay for a life, Ricketts said, clarifying that he meant Snook's life, not Theora's. A few character witnesses to point out what a decent citizen Snook was before he met Theora wouldn't hurt, either.

Ricketts was not happy with any of his choices but was hoping that if all else failed, he could at least convince the jury that Snook had not operated with prior calculation. The professor would spend the rest of his life in prison, but at least he wouldn't fry. Unfortunately for the Snook defense team, Chester took that last-ditch option away from them by having the grand jury indict Snook on first-degree murder only, without the so-called "lesser included offenses" of second-degree murder or manslaughter.

"That Chester is a pup who will not play fair," Seidel said when the lawyers learned of their client's indictment.

Over at the Franklin County Courthouse, Chester was also carefully weighing his options. He had a pair of confessions from Snook—the one he had wrenched out of the professor and the one Snook had given freely to the Columbus *Citizen* and the Cleveland *Plain Dealer* reporters. He was cautiously optimistic about the "official" confession being able to stand up in court against the coercion claim Ricketts and Seidel would undoubtedly bring, but even if that one fell through, there was nothing the defense lawyers could do to stop him from pointing out that twelve hours after confessing to the police, Snook had essentially repeated the same admission of guilt to the press.

Like the defense team, Chester knew certain items that had not been included in either confession, but he felt that those facts would work in his favor anyway. Snook's allegations of Theora's drug use and the obvious intimate nature of their relationship had been brought out in the papers, but the depth of the depravity to which Snook, at least in Chester's mind, had dragged Theora down to was still a secret. He knew Theora would also be on trial but believed that bringing those facts into the case would not help Snook.

Chester put himself in the place of Ricketts and Seidel and knew he held most of the cards. He had a sure winner with the confessions and felt confident that he could shoot holes in any self-defense argument. He was a little less sure about the insanity plea, but that didn't bother him too much. It was to his advantage to have this thing to trial as quickly as possible, and he was aggressively preparing arguments against the inevitable motions from the defense to delay. He had already sent a message to the defense when he had Snook indicted within twenty-four hours of his signed confession. Chester also wanted to send a message to his opponents about the strength of his case by not seeking the fallback options of the lesser-included offenses. To him, it was all or nothing. Either Snook went to the chair or he went free—and Chester felt very confident indeed that Snook would never again be a free man.

The Opening Act

Dr. Snook's case would be tried before the Honorable Henry J. Scarlett, the chief judge of the Franklin County Court of Common Pleas. He had not originally drawn the case but was forced to step in when Judge John King was incapacitated by severe dental issues. Scarlett was a capable jurist, but he was not prepared for the huge public interest in this case. Sensitive to public opinion, Scarlett agreed with Prosecutor Chester and wanted the case tried quickly. He was intent on making sure that justice was achieved and that Snook got a fair hearing, but some of his decisions during the course of the trial appear to have put expediency first.

Attorney Max Seyfert had been asked to join Snook's defense team for several reasons: he was an expert on appellate law and, in an unusual turn of events in an already unusual trial, would be needed to question Seidel and Ricketts when they took the stand as defense witnesses to bolster their claim that Chester had abused Snook's right to counsel and protection against self-incrimination. During the trial, Seidel and Seyfert would handle most of the questioning of witnesses when Ricketts became ill.

The prosecution team consisted of Chester and assistant prosecutors Paul C. Hicks and Myron Gessaman, who would eventually serve as mayor of Columbus and hold a seat on the Common Pleas bench. These attorneys made up three-quarters of the county prosecutor's office, not counting secretaries and investigators.

Thanks to the newspapers' hunger for getting the news out as soon as possible, the attorneys in the Snook trial would have a luxury that most

trial lawyers today can only wish for: near-instantaneous written transcripts of court testimony. Scarlett agreed to hire extra court stenographers who would work in fifteen-minute shifts during the trial and be paid by the press. While one stenographer was taking notes in the courtroom, the others would be feverishly transcribing their notes and making copies available for the reporters and attorneys. As a result, the legal teams had transcribed accounts of the day's testimony at their fingertips mere minutes after the words had been uttered. The Columbus newspapers took advantage of this unusual situation to publish the full transcripts (somewhat redacted to spare sensitive readers and children) each day. The papers did not mind the extra pages necessary to accommodate the testimony, as they found it quite easy to sell more advertisements because of the circulation boom brought about by the demand for any news coming from the courthouse.

By the opening day of the trial, forty reporters and illustrators had applied for press credentials, and a special press section with space for thirty reporters had to be built in the courtroom. Permission was also granted allowing the Associated Press to install a special telegraph station at the press table that allowed for news flashes to be sent across the wires as soon as they occurred. Reporters representing all the major wire services, as well as papers from New York to San Francisco, were scheduled to cover the event. A lengthy trial promised to be a windfall for the hospitality industry (both legal and underground) in Franklin County, as the reputation of national reporters for being hard-living big spenders was well deserved. The top names operated with nearly unlimited expense accounts because it was not unusual or frowned upon to pay for a story, for access to a scoop or to keep the competition from getting there first.

All of this publicity resulted in standing-room-only crowds for every open session of court. It was not unusual for the halls of the courthouse to be packed with hundreds of citizens eager to get a seat in the courtroom for even the most mundane proceeding related to the case. On most days, crowds would start gathering about 3:00 a.m. outside the courthouse, with young women making up most of the observers. When it was revealed that Snook would be testifying in his own defense the next day, 50 people lined up outside the ornate Franklin County Courthouse at 11:00 p.m. By 3:00 a.m., there were 250 people in line, and the papers reported that "peanut shells, cigarette butts, and newspapers littered the grounds" around the building.

Temperatures in the courtroom were sweltering, and no amount of fans could circulate enough air to provide the least bit of comfort. Most men not involved directly in the trial were in shirtsleeves, and on the first day of

Scandal and Murder at the Ohio State University

People would stand in line for hours for a chance to get a seat at the trial. *Courtesy of the Columbus Dispatch.*

Snook's testimony it was reported that four women fainted from the heat—including one who passed out twice but refused to relinquish her seat.

The first order of business before the actual trial began was to settle the insanity plea question. Ricketts made the motion for the bifurcated trial, and Scarlett ordered three panels of "alienists" to examine Snook's mental state. The three psychiatrists for the prosecution, who included the director of the State Hospital for the Insane at Columbus, reported back that Snook was not insane. The three psychiatrists who examined the doctor for the defense, headed by the chief at the State Hospital for the Insane at Athens, found Snook's reactions "very peculiar…and that he presents a very difficult problem for diagnosis." They asked for an additional sixty days to observe him in a clinical setting, questioning whether his evasiveness in answering their questions was emotional or pathological. Judge Scarlett received the report of the alienists representing the neutral court under seal and denied the defense motion for the additional observation time.

The Professor and the Coed

Annabelle and Flo at the Snook Trial was one of the many cartoons produced by the press during the sometimes-tedious testimony.

Faced with the likelihood that Snook would very likely not meet the insanity standard of not knowing the difference between a right act and a crime at the time of the alleged offense, the defense withdrew its motion for a two-part trial in return for a two-day postponement. Ricketts was not completely ready to abandon the idea of trying to show that Snook was insane when he killed Theora and was planning an unusual way of bringing the question in through the back door.

Snook was severely injured during the insanity observations when one of the defense alienists was attempting to draw spinal fluid to determine if the professor had any venereal disease. The spinal tap was botched, and for several weeks Snook was unable to sit upright and suffered from blinding headaches. When Scarlett refused to delay the proceedings to allow for his convalescence, Snook was brought to court wearing dark sunglasses. Scarlett ordered that a canvas beach chair be brought into the courtroom, and during much of the opening portion of his trial, observers could only see the top of Snook's bald head as he reclined in his chaise lounge wearing his sunglasses.

A little more than a month after Theora's murder and Snook's confession, seventy-five Franklin County citizens were summoned by Sheriff Harry Paul to report to the courthouse for possible jury duty. Those who received the summons had no doubt of what they might be asked to sit in judgment. This was normally the summer recess for the Common Pleas Court, and there was only one trial scheduled—the case of James Howard Snook for the murder of Theora Kathleen Hix. Ricketts and his fellow defense team members wanted as few female members on the jury as possible and nearly succeeded in having an all-male jury. Potential jurors and observers had a little hint of what might come up at the trial when they were asked whether they would be able to discuss "many matters concerning sex, sex

Scandal and Murder at the Ohio State University

Character sketches of the jury by Milton Caniff.

relations and matters perhaps disagreeable to talk about" with jurors of the opposite sex.

The voir dire, or jury selection, began on July 24, 1929, and was expected to take less than three days. Instead, the process took until August 1 and required questioning 106 potential jurors (a second summons of veniremen was necessary) until a jury of 11 men and one woman was seated. The official transcript of voir dire takes up one thousand pages of the three-thousand-page trial record and includes little more than seemingly endless iterations of nearly unintelligible exchanges like this:

> *Question by Mr. Seyfert: Now Miss Dysinger, have you any feeling or would this in any way influence you if in evidence it were shown that the accused had on different occasions committed adultery, and the deceased fornication—I might say that adultery is the illegal sex act of a married person; fornication is the same type of illegal sexual act of a single person—so the one is called a fornication on the part of the one that is not married and adultery on the part of the one that is married—if the evidence should show that on June 13, immediately prior to the—*
> *Mr. Ricketts: The alleged homicide.*
> *Question by Mr. Seyfert: To the alleged homicide, that the accused had committed the act of adultery with the deceased, would that in any way create in you a feeling of disgust or hatred towards the accused different than if the evidence wouldn't show that? I mean the adultery part as distinguished from the alleged homicide.*

The Court: The question as to whether it would tend to prejudice or bias?
Mr. Seidel: Yes.
The Witness: No.

With Dr. Snook uncomfortably reclining in his beach chair, opening arguments began August 2 and set the stage for the fireworks that would follow. Chester opened for the State of Ohio with a dry and straightforward recitation of the facts he intended to prove establishing Snook's guilt of first-degree murder. As Ricketts expected, Chester did not mention Snook's signed confession but did refer to the interview he gave to the *Citizen* and *Plain Dealer* hours later.

When his turn came, Ricketts opened with the assertion that he intended to "prove along the lines of the alleged admissions of the defendant himself, as we believe, will come under the rule of 'involuntary confessions.'"

Chester was on his feet in an instant with an objection.

"The state of Ohio has never offered—and never mentioned confessions," he shouted.

"I know you have not," Ricketts replied, ignoring the rule that his comments should be directed to the bench. "I know you have concealed it but we are going to open it up now. With the permission of the court."

Ricketts successfully argued that the question of the voluntariness of the confession and the interview involved matters of law (decided by the judge)

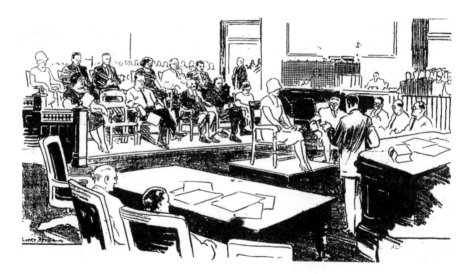

A sketch of the courtroom.

and fact (decided by the jury), and in such cases, the question should be answered by jurors with proper instruction by the court. In other words, he did not want Judge Scarlett to decide whether the evidence was admissible; he wanted the jury to use its judgment and sense of fair play.

For the next week, few surprises were unearthed as twenty-one prosecution witnesses ranging from farmer Johnson to coroner Murphy told their stories. The discovery of Theora's body was covered in excruciating detail, with special emphasis on Murphy's conclusion that the wound to Theora's throat had caused her death and chemist Long's analysis of the contents of Theora's stomach. Courtroom observers, many of whom had waited hours just to get inside the courthouse, learned the hard lesson that in reality, criminal trials are filled with hours of tedious testimony. Besides the constant bickering between defense and prosecution counsel and the obvious mutual dislike they shared, the one bit of exciting testimony during the state's case came when Murphy (gently) showed on assistant prosecutor Hicks how he believed Snook had administered the hammer blows and sliced Theora's throat and then, with more gusto, demonstrated the amount of force needed to crack a skull.

Even the reporters were so bored by the endless back-and-forth discussions of putrescence and cadaverine, phenolphthalein and *cannabis indica*, that they took to entertaining themselves as best they could and filing the results with their editors. Kenneth Tooil conducted an interview with a Blister Beetle eager to refute its species' reputation as an aphrodisiac ("I am glad to have this opportunity to defend myself against the slander that has been hurled at my good name," the bug said), while Caniff drew a scholarly study of Snook's hands at various points during a day in court.

Not to be outdone by Tooil, a competing columnist, George Tucker, "allowed" a "cell mate" of Snook's to use his space in the paper to explain "the real reason" why Snook killed Theora: "Say, youse guys is nuts. They been tryin' to find out why the doc done it fer a couple o' weeks and they ain't hit the nail on the head yet," the "jailbird" wrote. "Kin I tell you? I kin—an'—but lemme think." Tucker's con goes on to explain in the arcane cant of the underworld that just like "my poor brother Frank, the jumpinest old crab you ever lamped," Snook was the victim of shell shock as the result of firing so many pistol rounds during his life. Tucker's best work, however, was when he summarized the trial in doggerel verse:

The Professor and the Coed

"The Way of the Transgressor." A drawing that appeared in the Columbus *Citizen* drawn during Dr. Snook's preliminary hearing.

For he had slain
With cruel main
A woman—and they say
When murder's done,

Scandal and Murder at the Ohio State University

by six or one,
The murderers must pay.

There is a room
Of death and doom
Where murderers "go west,"
And in it there
A ghastly chair
Beckons: Heaven rest.

The evidence
Was quite immense.
Piled up by Chester's crew
It had the knife
That spilled her life
and blood-stained hammer, too…

Chester rested his case-in-chief by calling reporters Fusco and Howells to discuss what Snook told them during their midnight interview. He did not introduce the signed confession from Snook.

The defense called more than forty witnesses during the presentation of its case and highlighted the interrogation methods used to extract the first confession and the quality of the work performed by Murphy and Long. Defense chemists asserted that there was, in fact, no *cantharides* in the contents taken from Theora's stomach and that the *cannabis indica* had a negligible potency.

In particular, Murphy's reputation as a coroner was savaged, and the defense was able to produce four pathologists who contradicted the coroner's claim that it was possible to distinguish the particular wound that caused Theora's death. The defense claimed it was possible that a blow to Theora's temple that drove bone fragments into her brain was responsible.

In a surprisingly anticlimactic lead-in to the main event—the testimony of Dr. Snook—Ricketts called Snook's wife and mother to the stand to discuss their lives with their husband and son. Neither added anything of substance to the defense case, but Kenneth Tooil used the opportunity to wax eloquent about the event:

> *Realizing fully that the placing of Mrs. Helen Snook, the wife, and Mrs. Albert Snook, the mother, upon the witness stand was a bid for sympathy*

and nothing else and that so far as aiding Dr. Snook is concerned their testimony was virtually valueless, the incidents of the morning served to impress upon us that here is a living, breathing human drama and not a show of puppets or shadows on a screen.

It carried with it the undying loyalty of women for their men and mothers for their sons. It ripped bare two souls in torment and, in at least one instance, gave us a picture of how a woman will throw all to the winds in order to protect the man she once considered hers and hers alone.

Fully recovered from his spinal injury and looking as calm and collected as ever, James Snook took the witness stand before a packed, standing-room-only courtroom where the temperature approached that of a sauna in the late morning of August 7, 1929. By order of Judge Scarlett, no one under the age of eighteen was allowed inside, and the press reported that a majority of the spectators were young flappers anxious to hear the salacious details that had previously only been hinted at.

The defense, however, was not going to be rushed, and used most of the day discussing Snook's background, teaching history and the benign early days of his relationship with Theora. Seyfert spent nearly an hour questioning Snook on how he taught Theora to shoot and went into exacting detail about what types of weapons they used and at what distance they shot until he was prodded by Judge Scarlett to move on.

"Is there a point to this?" Scarlett asked. "I think we've covered it well enough."

But the defense had a three-year love triangle to explore and carefully tried to invoke an image of Theora as a controlling woman of loose morals. When Seyfert questioned Snook about the relationship between Marion Meyers and Theora Hix, all three prosecutors objected at once, arguing that Theora's character was off limits.

"We want to show the whole picture of this affair with two men and one girl," Seyfert replied.

"What does that have to do with the murder?" Scarlett asked.

"It shows the character of the decedent," Seyfert said.

"That's it!" Chester shouted. "You cannot do that."

Seidel then spoke up, explaining that the defense intended to show that the details of the three-way relationship would help bolster its claim of insanity. When Scarlett asked what that had to do with any question of insanity, Ricketts said, "No sane man could have entered into such an arrangement as existed between these three persons. They were all insane."

"You mean they were insane all the time?" asked an incredulous Chester.

"We intend to show that the mental derangement had its inception at the outset of the intimacies between Dr. Snook and the girl and at the point where Meyers entered the picture," Seyfert said. "We contend that in the spring of 1927, the gradual unbalancing of Dr. Snook's mind was under way. When all this started Dr. Snook was a normal, hard-working man, but the gradual change in his mental ability finally brought about the breaking point."

Seidel added that the defense had to show this gradual breaking down of Dr. Snook's mental attitude to place its hypothetical questions of insanity before the psychiatrists and alienists. Scarlett ruled in favor of Snook but admonished the jury only to use the testimony as it pertained to the sanity of the defendant and not to determine Theora's character.

For the rest of the afternoon, Snook told about how the three parties in the relationship got along, emphasizing that Theora told him in no uncertain terms that she intended to keep seeing both men. "She told me that she had been going out with him and she intended to continue so inasmuch as I couldn't go," Snook testified. "I asked her something about whether it would be satisfactory to her, and she said 'very much so.'"

The triangle broke apart, Snook testified, when Meyers proposed marriage and Theora turned him down.

Testimony then turned to a second prong in the defense's insanity argument—drug use by the lovers. Up to the time he took the stand in his own defense at his trial, Snook claimed that Theora was "hounding and hounding" him for narcotics and once injected cocaine in his presence. Legal access to cocaine was still possible in 1929 but was closely regulated by the Harrison Narcotics Act of 1914, which allowed physicians to prescribe the stimulant (cocaine was included in the law despite not being a narcotic) under limited circumstances.

Trial testimony explained why *cannabis indica* in powder form was found in Theora's stomach. *C. indica* was a normal component of any drugstore or physician's pharmacopoeia in both liquid and pill form. It was also regulated by the Harrison Act and available by prescription. The news that Theora used cocaine as an anesthetic and marijuana was not as shocking to the public as one might expect. The *cannabis* was prescribed as a tranquilizer and sleep aid. Unlike modern medicinal marijuana, in the 1920s the drug was not distributed legally in its natural vegetable form.

Regarding other drugs, Snook was unequivocal in his claims that Theora used them and encouraged him to do so, as well.

On the stand, Snook was questioned about these drugs and said the pair shared "thyroid extracts and thyroxine," which Theora was taking for a thyroid condition. "She had a test that her metabolic rate was low and that if it was brought up to normal she would be pepped up some," Snook testified. "So we took some of that and then she urged me to try some, that it might pep me up, not knowing if my metabolic rate was low or not."

Snook testified that Theora also used a more dangerous drug that was a holdover from the Victorian era: belladonna and its active ingredient, atropine. Other side effects of belladonna are blurred vision and visual distortions. Prolonged use was linked to blindness. The alkaloid toxins in the leaves of belladonna, also called "deadly nightshade," cause hallucinations and delirium. Used for centuries as a cosmetic, belladonna was put in the eyes, causing dilated pupils that were considered attractive. Although by the late 1920s belladonna and atropine had been long discarded by the cosmetics business and was being phased out in favor of safer sedatives by the pharmaceutical industry, its popularity as an ornamental plant made it easy to find.

"Veronal (a barbiturate) was used," he testified. "Barbatol they call it and neanol, and there were a few others that they used in laboratory experiments that I really cannot name now."

Theora's interest in drugs was aroused by the pharmacology courses she was taking in late 1928, Snook said. "As quickly as the drugs were revealed to her, she experimented with their use," he testified. "She wanted me to take them too, but I was unacquainted with their reaction on the human body. When she insisted I finally took some tablets that affect the action of the thyroid. They pepped me up quite a bit."

Secrets Revealed

The Thursday morning session of Snook's trial began chaotically. When the public learned that the confessed killer was about to take the stand, the crowd inside the courthouse swelled to the point where the noise outside the courtroom from the curious throng made it difficult for the participants in the trial to hear. Extra deputies and bailiffs were called in to control the mob that became unruly once they realized they were missing what promised to be the most exciting part of the trial. Those who had waited overnight only to be denied entrance because the courtroom was full hurled abuse on the bailiffs and tried any means possible to get into the room. They forged press credentials, invented newspapers to work for, asserted friendships with the lawyers and judges, begged and bribed. Finally, a frustrated Judge Scarlett issued a blanket order to the deputies to arrest anyone who caused the least bit of commotion outside the courtroom. Those lucky enough to be inside knew better than to draw any attention to themselves lest they draw the ire of the judge and trade their place in the courtroom for a seat in the jail.

Once everything settled down and Scarlett gained control, Snook was brought in from the jail and took his place on the witness stand. Today, the defense planned to go over the events of June 13, 1929. Finally, the public was about to hear the story of the death of Theora Hix from the only person to witness it. Dr. Snook's testimony was expected to be unlike anything ever heard in a Columbus courtroom, and it turned out to be everything the public wanted and more.

THE PROFESSOR AND THE COED

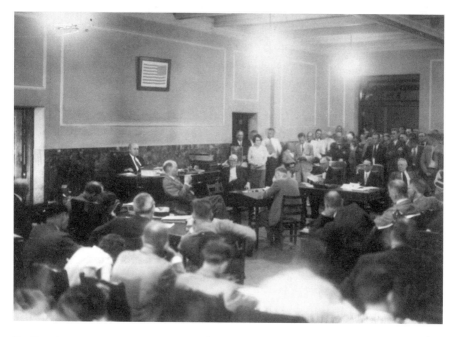

Dr. Snook testifies at his murder trial. *Courtesy of the* Columbus Dispatch.

But Seyfert began the day having Snook discuss the financial arrangements he had with Theora. She was by no means a kept woman, but she did receive a great deal of money from her lover. They considered the money loans, and Snook kept track of the debits and credits in a green notebook. In July 1928, Theora repaid a six-month loan of $1,000 with interest, but by November of that year she had convinced the professor to advance her another $700.

"She felt that the relations with me might be found out and if so she wanted to get out of town in a hurry," Snook testified. "She didn't want to be expelled from school. She wanted money available to go without any preliminaries, and therefore she wanted this fund in her control."

The discussion then turned to the sexual relations between the lovers. Snook said Theora was unsatisfied by his sexual performance and pressed him to engage in acts that in the 1920s were considered "not matrimonial" and "unnatural."

Question by Mr. Seyfert: When was the first time that your relations, sexually speaking, were unnatural with Miss Hix?
Answer: Just about the first of April.

> *Q: I just want you to relate now, Dr. Snook, as near as you can, without going into too many details, in a generalized way, just what took place between you and Miss Hix?*
>
> *A: Finally she insisted that she be allowed to satisfy it in the way she wanted to. She did so by taking my privates in her mouth.*

Snook's revelation was earth-shattering. At a time when fornication—intercourse between unmarried people—was a crime, oral sex was not only unlawful and grounds for divorce, but it was considered a sexual perversion of the highest order. But oral sex was not the only activity Theora wanted, Snook said.

"One time she said she wanted to hurt me or scratch me and referred to a statement in one of the books on sexology she had in which somebody said it always gave them a lot of satisfaction to scratch somebody else," he said.

At last, there was nothing else to talk about but the events at the shooting range. For the most part, Snook's testimony leading up to the actual slaying differed little from his previous statements. However, at the point where the lovers arrived at the range, Snook's story took an unexpected turn. The courtroom was held in silent thrall as the professor explained exactly what prompted his deadly assault on his paramour. They ended up at the shooting range, Snook claimed, not because he was looking for a place to distract her from her bad mood but because they were going to make love.

"She said 'I like to go out some place farther where I can scream,'" Snook testified.

Once they arrived at the shooting range, they decided to try to have sex inside the tiny Ford coupe. They had never attempted it in the car before, and the session was not successful.

"We proceeded to have sexual intercourse in the machine and the machine was rather cramped, and the position of the cushion was not satisfactory, and I had been using prophylactic tubes and didn't have any along," Snook said in a rambling explanation of the attempt. "We made the best of it and so it ended and it was unsatisfactory for both of us. We resumed our place in the machine…she didn't say anything, sat up in position there without ever saying a word, and I looked around…and I said 'we better go,' and I started the engine, and she reached over and turned it off, she said 'not now.'"

Snook said Theora went into one of "those kind of spells [where] there is nothing much I can say to her, she just waits until she says something else." After a bit, he said they needed to get going.

"You are not going," Snook testified that Theora said. "You are not going home over the weekend."

On the stand, Snook began to break down as he told how Theora then threatened his mother, wife and child.

The professor had reached the point in his story where the courtroom observers expected to hear him describe how Theora had reached for her purse and Snook was afraid she was going for the Derringer. No one could have anticipated what he said next.

> *Then she said I simply have got to do something for her. She said "you have got to help me out," and with that, she grabbed open my trousers which had been buttoned up, and went down on me then, and she didn't do it very nicely and she bit me and grabbed the right hand and got a hold of the privates and pulled so hard I simply could not stand it, and I tried to choke her off, and I couldn't get her loose that way, and then I grabbed her left arm and gave it a twist, and finally pulled her loose, partly and she grabbed back again and all I could do was to hold her head close up to keep her from hurting me, and turn around and got something, and I got hold of something out of this kit and hit her with it, and I didn't hit her very hard; I finally got her loose and twisted her away, very nearly twisted her arm off, I thought, to make her get up in the machine, and she sat up there a little bit and she said, "Damn, you. I will kill you, too."*

Snook went on to describe to the stunned courtroom that Theora then reached for her purse and he feared she was going for the gun. As he was doubled over in pain, Snook saw Theora take the purse and slide out of the car.

"I had so much pain and I tried to straighten up," he continued. "All at once it flashed in my mind that she was getting out and I knew if she got out she would shoot me. That is what I expected her to do and she grabbed her purse and slid out of the machine."

Snook testified that he hit Theora with the hammer four times before he blacked out. "I am sure I didn't hit her but three times in the machine and once when she got out, and I can't imagine any more licks with the hammer than that," he told the court. "I couldn't straighten up, and next thing I knew I was sitting on the running board of the machine, doubled over with my elbows on my knees." At this revelation, Snook broke down again, prompting a call for a recess.

Scandal and Murder at the Ohio State University

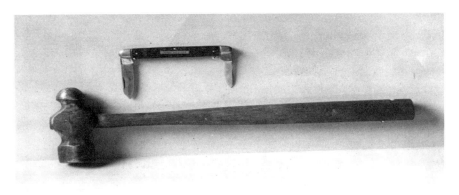

The hammer and knife used in the murder of Theora Hix. *Courtesy of the* Columbus Dispatch.

When the court resumed, Snook continued his story. "I was sitting there stooped over and crying, tears running down my face. I saw the girl lying there and I spoke to her and I didn't get any reply, and I raised up and looked around, and that is the first time I realized that somebody might come around there—I don't know just how I got in the machine, but I got in and hurried away."

With that, Seyfert turned the witness over to Chester. The prosecutor did not immediately go into the events of June 13 but instead began his cross-examination with the letters from "Janet." In particular, he wanted Snook, who admitted writing them, to explain the significance of the missive where he wrote that he had been "wanting to snip them both for some time."

"Some little time previous, sexual intercourse had not been satisfactory to Miss Hix, and she complained of my general condition," Snook replied. "She said that I needed some kind of treatment to improve my general health and that she was not as satisfied as she had been." Snook said he knew of such a treatment, called a "Steinach Operation."

In the beginning of the twentieth century, Dr. Eugen Steinach of the University of Vienna advocated a form of vasectomy not as a means of birth control but to restore sexual vigor and enhance pleasure. Experimenting on the testes of mice, Steinach cut the sperm-transporting vas deferens, which increased blood flow to the testes and caused an enlargement of endocrine-producing cells, resulting in "insatiable interest in sexual activity," Steinach believed.

To appease Theora, Snook decided on a radical solution—one that ranks as one of the most shocking in a case of never-ending surprises: in an effort

to improve his sexual performance, Professor Snook performed the Steinach Operation on himself. In his testimony, Snook described the procedure as "somewhat successful."

The reporters made no mention of Snook's self-administered treatment and, unable to share the exact details of Snook's testimony with their readers, were forced to write that Snook killed Theora because "she mistreated me terribly and I couldn't stand the pain."

Endgame

Snook was back on the stand for more cross-examination Friday, and Chester expertly led him through the assault and murder in minute detail, down to the placement of Snook's feet during the attempt at lovemaking in the vehicle. Courtroom observers who missed the prurient details of Snook's testimony the day before were given a chance to hear the entire story over again in a verbal form of slow-motion replay:

> *Question by Mr. Chester: Was the right door of the coupe open or closed?*
> *Answer: Open.*
> *Q: Was your right foot out or your left foot out?*
> *A: Left foot.*
> *Q: Your left foot was out of the car and your right foot, was it out or in?*
> *A: It was in.*
> *Q: It was in the car. Where was it, Doctor?*
> *A: Pushed up around the pedal, as best I know.*

By taking Snook step by step through the details of that night, Chester was effectively negating Snook's claim that he could not remember the events surrounding the murder. He wanted the jury to reason that a man who could remember the exact position of his feet during sex was lying when he said he could not remember cutting the throat of his lover a few minutes later.

Having established the professor's ability to remember details, Chester handed Snook the hammer and had him demonstrate how he hit Theora.

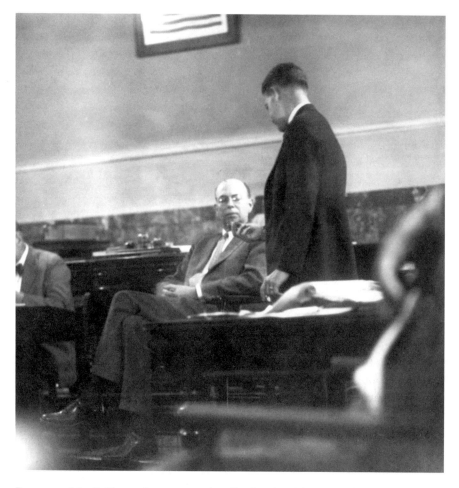

Prosecutor John J. Chester Jr. cross-examines Dr. Snook at his trial. *Courtesy of the Columbus Dispatch.*

For the prosecution, this was a masterful move; not only did it give the jury a vivid picture of what the professor looked like with the hammer in his hand, but it also put the doctor in the difficult position of having to swing the weapon. If he hit it hard, he would appear violent, but if he laid up, the jury could get the impression that he did not hit Theora with enough force to kill her. Snook fell into the trap and lightly tapped the witness chair.

When Snook denied remembering how he cut Theora's throat, Chester moved on to Snook's interrogation. Rather than introduce the signed confession at that time, the prosecutor used the notes of the questions and answers during the third-degree session. For more than an hour, Chester

read the interrogatories and responses, and Snook responded with either denials of saying what was attributed to him or saying he did not remember providing such an answer.

"You admitted that you cut the girl's throat to relieve her suffering after you beat her with the hammer, did you not?" Chester asked.

Snook denied ever saying that.

"Then if we say you did, we are liars?"

"Yes, you are."

Snook asserted that the words in the confession he signed were drafted by Chester and that he only signed it under duress. By the end of the cross-examination, Snook had denied nearly every statement attributed to him by the police and the reporters Fusco and Howells.

The sentiment was clearly against Snook after his testimony. Kilgallen reported that at the end of his time in the dock, "Snook was taken back to his cell last evening stripped of the glamour of his 'iron nerve.' He is shaken and spent by two days of examination on the stand."

The subhead in the *Dispatch* story on the cross-examination read: "Killer's memory is conveniently poor at crucial points: Makes poor showing in re-enactment of death scene with prosecutor Chester and insists mind is blank as to what he did after fourth blow with hammer was struck."

There was little left for the defense to do after Snook testified except to plow ahead with the argument that the confessions were coerced. On Saturday, Seidel and Ricketts both took the stand to testify how Chester denied them access to their client and threatened to "ruin" Seidel unless he secured a confession from Snook. Even this fell flat, as Chester got Ricketts to admit that it was because of a deputy's actions—not the prosecutor's—that the defense obtained the injunction allowing them access to their client. Ricketts conceded that he got the court order before he even spoke to Chester.

The defense team took the tactical step of not pursuing the insanity argument and announced at the end of its case that it would not call any psychiatrists to discuss Snook's mental state. The move was prompted in part by the hope that an appeals court would rule against Judge Scarlett's decision not to allow the defense experts sixty days to observe their patient. Scarlett's decision, they would argue, cut off one avenue of defense and made the trial unfair.

Almost as an aside, the defense was able to establish through medical testimony that Snook's genitals showed signs of scarring due to an attack of the sort he described. A prosecution-appointed physician also inspected the professor and did not dispute the defense's contention. What effect that might have had on the jury remained to be seen.

Cover of the pamphlet published shortly after Dr. Snook's trial with his unexpurgated testimony.

Outside the courthouse, the Columbus police were busy tracking down copies of Snook's testimony that were being sold in booklet form under the title *The Murder of Theora Hix: Dr. Snook's Uncensored Testimony*. Some enterprising stenographer had taken the more prurient parts of Snook's story as he told it from the witness stand and arranged for it to be printed and bound with a hand-drawn cover featuring the professor's face. Almost as soon as the seventy-page book hit the streets, it was declared obscene, and the police were ordered to confiscate every copy they could find. No more than a handful of the booklets still exist.

The closing arguments on both sides touched briefly on the evidence introduced in the case and reiterated the arguments from the opening statements, but on each side it was the personality and character of the defendant and victim that received the most attention.

In his closing argument, Seyfert addressed Theora's character, first apologizing for having to do so. "I would like to say 'peace to her ashes,' but I cannot do that with the life of a man at stake," he said. "She has to be ridiculed to be pictured as she was. She was the type that was quiet, but sneaky."

Seidel piled on. "If Snook wrote those letters that were read to you, then Theora must have written something first which caused Dr. Snook to write such replies," he said. "And she saved those letters. They were deadly weapons. She was a scheming two-man woman—one for the afternoon, one for the night."

Assistant Prosecutor Gessaman described Snook as "a man who has lied to the police, lied to the prosecutor, lied to his own attorneys, who is now coming on the stand, trying to blacken this girl's character, trying to say he was afraid of her to escape the electric chair."

Chester finished the state's arguments by cursing Snook, comparing the heinousness of his crime to that of Leopold and Loeb and demanding that the jury uphold the honor of the State of Ohio by finding Snook guilty. At the conclusion of his argument, widespread applause filled the courtroom, prompting an objection by Ricketts and an admonishment to the jury from Judge Scarlett.

Scarlett addressed the jurors at length about the confessions, advising them how to determine whether the confessions were voluntary.

> *The ultimate question for your determination is whether or not...improper inducements did in fact cause the confession, or confessions to be made, or whether such confession or confessions was or were the free and voluntary act of the accused. All the surrounding circumstances, the defendant's strength or weakness of mind, his knowledge, his demeanor, etc., must be looked to by you to determine whether he was affected by the promises or threats, if any, and made the confession or confessions as a result of such undue influence, or freely and voluntarily.*
>
> *Consider separately the circumstances under which each of the alleged confession or confessions were made by the defendant. If you find any or all of the confessions to be involuntary, you will entirely disregard any such confession or confessions. This rule is based upon the belief that confessions so extorted are untrue, or at least unreliable, and therefore must be rejected.*

There was one final shock to come in the trial of Dr. James Snook, and this time it was delivered by the jury. After three weeks of testimony by more

than sixty witnesses, the jury came back with a guilty verdict in just under thirty minutes. Snook received the verdict with the same coolness he had exhibited throughout the entire ordeal.

Afterward, a juror said the first fifteen minutes of the deliberations were taken up by selecting the foreman and praying for divine guidance.

A Picnic in the Death House

There was only one sentence for first-degree murder at the time—death in the electric chair—and a week after the guilty verdict, Judge Scarlett condemned Snook. He was taken to death row at the state prison on the other side of the city to await the execution of his sentence. Sharing his cell with two other condemned men, he spent his time listening to baseball games on the radio and reading.

Justice moved quickly, and on November 22, 1929, the Circuit Court of Appeals rejected Snook's appeal, finding that his confession was not coerced and that Judge Scarlett did not abuse his discretion by refusing to grant the sixty-day continuance for mental observation.

The court strongly criticized Chester and the police for the manner in which they got Snook to admit his crime but, in the end, said it did not really matter.

> *We agree with the contention of counsel for defendant that the striking of a prisoner by one who has authority over him, unless he is in actual resistance, is unjustifiable. The defendant has a right to confer privately with his own legal adviser at all reasonable times. However, the character of a confession is not determined by a denial or an abuse of defendant's right, but by the effect upon him of such acts. Such effect it was the function of the jury to determine.*
>
> *Although it is not necessary for us to so hold, we are of opinion that, without the confessions in this case, the record is sufficient to support the verdict of the jury.*

The Professor and the Coed

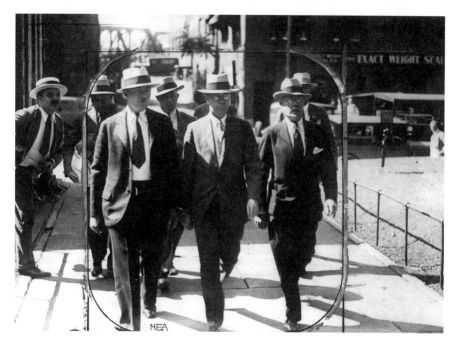

Handcuffed to Deputy Ralph Paul, Dr. Snook enters the Ohio State Penitentiary with Sheriff Harry T. Paul. *Courtesy of the* Columbus Dispatch.

Not only did the three-judge panel affirm the fairness of the trial Snook received, but it also took the unusual step of commenting on the nature of his crime. "A recital of the details of the killing of Theora Hix, as appearing in the testimony, discloses a most vicious and brutal murder, designed and executed by a cool and calculating individual, and no excuse or justification therefore is to be found in the record." The only chances left for the professor were the Ohio and U.S. Supreme Courts or, failing those, a commutation from the governor. As he expected, no one came to his rescue, and the Ohio Supreme Court set an execution date of February 28, 1930.

Snook spent most of that day with his wife and, in a special treatment for a condemned man, had his final meal catered. He partook of the repast with his wife, his personal minister and the prison chaplain and two friends. "We all ate heartily, there was no restraint," said the Reverend I.E. Miller, Snook's minister. "It was as if we were on a picnic." In what has become a staple for execution day news reports, the press duly shared with the public the contents of the last meal: fried chicken, lamb chops, mashed potatoes, ice cream and coffee.

Scandal and Murder at the Ohio State University

Miller refused to share Dr. Snook's last words, but in the days leading up to his execution, the professor granted one final interview, during which he made one last attempt to redeem his character.

> *I make this statement because I want an unsympathetic public to know the facts. I did not intend to kill her. I was under a great nervous strain and in a weakened physical condition and I cracked. I make this statement, fully knowing that it will not stay the hand of the thing they call Justice, but instead to correct a wrong impression that an infuriated and incensed public has had of those involved. I repudiate absolutely, the confession, wrung from me by third degree methods.*

At 7:00 p.m. on the last day of February—261 days after he murdered Theora Hix—a collected but red-eyed James Howard Snook entered the death chamber in the Ohio State Penitentiary to pay for his crime. He said nothing as he sat in the chair, and only as the straps were being tightened across his chest did he display anything resembling emotion. He blinked his eyes rapidly, clenched his fists and bit his lower lip.

Three jolts of nearly two thousand volts administered over a three-minute period were necessary to kill the professor, and the execution was not a particularly "clean" one. At the first shock, Snook strained against the wide straps holding him in place until the current was turned off. "The fists drew up into knots and the bald head blistered terribly from the heat of the 'thunderbolt,'" wrote International News Service reporter H.T. Hopkins. "Thin wisps of smoke curled up from the electrodes on his head and leg. The smell of burned human flesh pervaded the chamber into which two score people had crowded to watch the man die."

Snook was pronounced dead at 7:09 p.m.

"It is over," said Melvin Hix from the office of his Columbus attorney, Boyd Haddox. "Thank God for that. The air seems cleaner about me. I can breathe easier."

Helen Snook waited in the office of prison warden P.E. Thomas until the execution was over, unaware that the warden had sold a story of a purported interview with Snook to the *Dispatch* and *Plain Dealer* to be published the next day. The warden's story, which is almost certainly fiction, contradicted everything Snook ever said about the case and claimed to reveal the "real" motive for the crime.

> [The] *testimony, Dr. Snook told me, was absolutely false in its entirety. Snook's only regret was that the "story did me more harm than good and probably had something to do with the severity of the verdict." He then went into length about the character of Miss Hix saying she had threatened to expose the whole affair and ruin him socially and professionally. This fear of disgrace and loss of position caused him to carry out this decision… to carry out his plan to kill her when they met the night of the murder…*
>
> *He admitted that the mutilation of the body was planned to make the crime look like the work of a fiend.*

A few days after the execution, Snook's body was interred in Greenlawn Cemetery in Columbus. The grave is marked with a pseudonym. Theora Hix's body was returned to her childhood home in Long Island.

Helen Snook remained in the Columbus area with her daughter, living under her maiden name until her death in the late 1970s.

Bibliography

Anonymous. *The Murder of Theora Hix: Dr. Snook's Uncensored Testimony.* Columbus, OH: 1929.

Associated Press. "Comedy Enters Tragic Trial of Dr. Snook." August 12, 1929.

———. "Defense Paints Snook as Victim of Romance." August 7, 1929.

———. "Defense Tries to Show Co-Ed Used Narcotics." August 10, 1929.

———. "Doctor Arrested for Questioning in Hix Murder." June 15, 1929.

———. "Doctor Snook Is Executed." February 28, 1930.

———. "Dr. Snook in Witness Box." August 7, 1929.

———. "Snook May Face Charge of Slaying Co-ed." June 17, 1929.

———. "Snook Tells of Co-Ed Love." August 7, 1929.

———. "State Seeking to Find Flaw in Testimony." August 9, 1929.

———. "Warden P.E. Thomas Says Veterinary Confessed Just Before He Died." March 1, 1930.

Bibliography

Circleville Herald. "Long-Awaited End to Sordid Murder Case Comes with Dr. Snook's Death." March 1, 1930.

Cleveland Plain Dealer. "Professor Blames Co-Ed for Murder." June 21, 1929.

———. "Snook Planned Perfect Crime." March 1, 1930.

Columbus Citizen. "Coroner Murphy Reconstructs Story of Miss Hix's Killing." June 15, 1929.

———. "Dr. Snook Hi-Hats Other Prisoners in Jail. Shell-Shocked, One Thinks." July 29, 1929.

———. "Professor Sorry He Killed Co-Ed." June 21, 1929.

———. "Relive Co-Ed Slaying." August 8, 1929.

———. "Scientists Say Slayer May Have Been Epileptic." June 15, 1929.

———. "Shrewdest Man Ever Grilled, Police Say." June 20, 1929.

———. "Snook, Wife, Chemist to Face Investigators." June 18, 1929.

———. "Two Quizzed in Range Murder." June 15, 1929.

Columbus Dispatch. "Chester Hit Me, Reporter Quotes Dr. Snook." August 7, 1929.

———. "Clash at Police Hearing." June 18, 1929.

———. "Common Sense Solved Mystery, Chester Says." June 20, 1929.

———. "Crops Worker Afraid Hix Was 'Shadowed.'" June 19, 1929.

———. "Curiosity and Hunt for Thrills Draw Many to Scene of Co-ed Murder." June 19, 1929.

———. "Cussing Didn't Shake Snook, Detective Avers." August 8, 1929.

Bibliography

———. "I Planned to Kill Her." March 1, 1930.

———. "Last Supper Just Like a Friendly Little Party, Minister Says." March 1, 1930.

———. "Miss Hix Most Bashful and Worst Man-Hater in Prep School, Classmate Tells." June 19, 1929.

———. "No Chance of Guilty Plea." July 20, 1929.

———. "Snook Admits Love Nest." June 15, 1929.

———. "Snook Confesses to Murder after All-Night Grilling." June 20, 1929.

———. "Snook Executed." March 1, 1930.

———. "Snook on Stand, Reveals Life with Theora." August 9, 1929.

———. "Snook Trial in Rhyme." August 8, 1929.

———. "Snook Wanted to See Sneer on Face of Murdered Co-Ed." June 21, 1929.

———. "Theora's Parents Stern in Training." July 22, 1929.

———. "Tooil Thinks Defense Needs a Houdini." July 25, 1929.

Fass, Paula S. *The Damned and the Beautiful: American Youth in the 1920s*. N.p.: Oxford University Press, 1977.

Inbau, Fred E., John E. Reid, Joseph P. Buckley and Brian C. Jayne. *Criminal Interrogations and Confessions: Essentials of the Reid Technique*. N.p.: Jones and Bartlett, 2005.

International News Service. "Calm, Self-Possessed As He Tells Story of Intimacies with Co-Ed." August 7, 1929.

BIBLIOGRAPHY

———. "Mrs. Snook Leads Husband to Death Cell from 'Picnic.'" February 28, 1929.

———. "Snook Re-enacts Murder of Theora." August 9, 1929.

Lima News. "Alienists Not to be Called for Defendant." August 12, 1929.

———. "Defense Puts Blame on Theora." August 14, 1929.

Lock, Stephen. "O, That I Were Young Again: Yeats and the Steinach Operation." *British Medical Journal* 287 (December 1983): 24–31.

Newark Advocate. "Jurors Selected in Snook Trial." July 24, 1929.

———. "Love Nest Is Bared in Ohio State Murder Probe." June 17, 1929.

———. "U.S. Takes Part in Hix Probe." June 17, 1929.

Osterburg, James W., and Richard H. Ward. *Criminal Investigation: A Method for Reconstructing the Past.* N.p.: Anderson Publishing, 2007.

Piqua Daily Call. "Release One Suspect in Columbus Murder." June 19, 1929.

Portsmouth Daily Times. "Dr. Snook Pays Supreme Penalty." March 1, 1930.

Snook v. Ohio. 34 Ohio App. 60; 170 N.E. 444; 1929 Ohio App. LEXIS 358.

Trial Transcript, *State of Ohio v. James Howard Snook.*

United Press. "Chain of Circumstantial Evidence Links Dr. Snook to Ohio Murder Mystery." June 17, 1929.

———. "Clever Actress on Life's Stage Was Slain Woman." June 19, 1929.

———. "Dr. Snook Pits Cold Personality Against Prosecutor's Assault." August 9, 1929.

———. "Evidence Piles up as Sleuths Probe Slaying." June 16, 1929.

Bibliography

———. "Police Search for Killer of State Student." June 15, 1929.

———. "Prosecutor Has Role of Girl in Crime Pantomime." August 10, 1929.

———. "Strange Girl, Pretty, Smart, But with Few Friends—That Is the Description of Murdered Co-ed." June 16, 1929.

About the Author

Mark C. Gribben is a writer living near Columbus, Ohio. A nationally recognized crime historian, his work has appeared in many publications, online and on television. He began his writing career as a courthouse reporter and newspaper editor. His true-crime website was recognized by *Rolling Stone Magazine*, which called it "a riveting site documenting notorious crimes from the past two centuries." This is his third book.